LEARNING TO PAINT

BERNARD DUNSTAN

LEARNING TO PAINT

WATSON-GUPTILL PUBLICATIONS · NEW YORK
PITMAN PUBLISHING · LONDON

Paperback Edition
First Printing, 1978

First published 1970 in the United States and Canada by Watson-Guptill Publications,
a division of Billboard Publications, Inc.,
1515 Broadway, New York, N.Y. 10036

Published in Great Britain 1972 by Pitman Publishing Ltd.,
39 Parker Street, Kingsway, London WC2B 5PB
ISBN 0-273-01226-6 Pbk.

Library of Congress Catalog Card Number: 77-125843
ISBN 0-8230-2701-5 Pbk.

Manufactured in U.S.A.

CONTENTS

ACKNOWLEDGMENTS

Much of the material in this book has been developed from a series of articles which first appeared in *The Artist*. I have used it here with the full permission and cooperation of the editor of that periodical, Frederick Parkinson, and I would like to thank him.

I would also like to thank Don Holden, editor of Watson-Guptill Publications, for encouraging me to develop these ideas into a book; and my wife, who has always been prepared to discuss points that have arisen and who has made many valuable suggestions from her own experience of teaching and painting.

INTRODUCTION

This book is really about using our eyes. Everyone, of course, uses his eyes to some extent, and for practical purposes, all day long. The painter has to go further than this. His eyes have got to be used, so to speak, at full stretch, used more lovingly and yet, in a curious way, with more detachment than other peoples' are.

Widening the range of our visual awareness—opening our eyes, if you like—seems to me the most important thing about learning to paint or draw. It's also something in which teaching can be of the greatest help, and where even a book may be of some assistance.

The mechanics of "how to paint" aren't the concern of this book at all. I doubt if the subject can be satisfactorily taught, anyhow. Although there's a lot in the later sections about design, color, and what generally goes on within the bounds of the canvas, none of this information is related to particular styles of painting; I hope that readers will be able to find in these sections something that will be of assistance, *whatever* sort of painting they want to do.

It isn't until we start painting that we find out how little we have seen before. In everyday life, we tend to use our eyes in specialized ways. When driving a car, for instance, we concentrate on what we need to see —the road, other traffic, and signs. We "read" what comes in front of us for the particular information we need. This is an extreme example of what happens in a large part of our daily life: the brain monitors the information fed to it by the eyes and extracts only what it needs for the purpose at hand.

The painter, perhaps, is almost the only person in our very specialized society who uses his eyes really objectively and without blinkers. He is able to accept without choice or preference all the visual stimuli that come to him.

This type of looking is one of the justifications for drawing and painting in a figurative way, however bad the results may be. At least the painter uses his eyes in a way that they can seldom be used in everyday life: at full stretch, accepting and examining a totality of experience. This visual experience can be an important extension of the human consciousness, one that requires a certain humility on the part of the artist—an absorption in the character and reality of the subject, rather than merely in the production of an acceptable end-product, the picture.

At a later stage in a painter's development, he may, of course, return to a highly selective or specialized vision—a personal style of figurative or non-figurative painting. In his earlier training, though, I'm sure he

should be as wide as possible in his sympathies, concerned with observing nature, and not merely with achieving a style.

Two things are particularly important in developing visual awareness, a process which is so much a part of learning to paint. The first is that we tend to develop preconceived ideas about what things look like, or how they should be represented—conceptions often based on the way other artists have drawn or painted them. The second is that our looking is normally directed at isolated objects like the orange on the breakfast table, whereas in painting we need an awareness of relationships *between* things as well; we must learn to see all the objects on the table at once. Both these factors can prevent us from seeing clearly. The education of the eye consists, to quite a large extent, in developing beyond these limitations.

In the past, the student was faced straight away with a complicated subject, such as a nude model or an intricate still life; in the process of trying to represent this subject, he was gradually supposed to grasp the relationships of shape, color, proportion, and so on. But these subjects are so complex—so many things have to be grasped at once—that the beginner tends to get lost or discouraged; he's then tempted to fall back on preconceived ideas. When this happens, he consciously or unconsciously makes his version fit with what he remembers about other artists' "ways of doing it."

If, on the other hand, we draw something we don't know about, or have never seen before, we're forced to look at it freshly and to put down as clearly as possible just what we see. And if the subject is reasonably simple, it is easier to concentrate on basic relationships. Obviously, the sensible approach is to select a subject that illuminates and helps us concentrate on *particular* aspects and problems of drawing and painting.

Much art teaching today uses this approach. A student at an art school is likely to be confronted with a series of projects which has been designed with the intention of opening his eyes to many different possibilities. In carrying out these projects, he may find that his preconceived ideas of what things look like, and how they should be painted, are shaken up.

One limitation of this kind of teaching, however, is that many of the instructors are abstract painters; or, at any rate, their teaching tends toward non-figurative work. The purpose of this book—which has developed out of fairly extensive teaching experience—is to attempt the same kind of approach in terms of fig-urative painting. Each section, consequently, is designed to help illuminate a particular problem that is likely to come up in any kind of realistic painting. Each point is clarified, as far as possible, by an example of an actual picture by an old or modern master; and in many cases a simple project is suggested which the reader can carry out in his own way. These suggestions, by the way, have all been used in the course of actual teaching.

Modern methods of art teaching can develop into an academic approach as rigid as the old ones, and dogmatic courses of "basic design" and color theory may have the effect of closing, instead of opening the eyes.

You cannot be dogmatic about learning to paint. Every student is unique and has different needs; the subject cannot be treated, as other ones might be, as a tidy progression from "easy" to "difficult." A student could go through a whole course of carefully worked out projects and exercises, and at the end still be wholly incapable of painting anything of his own with conviction.

This book, then, should be used not as a self-contained "method," but in conjunction with the reader's own natural development as a painter. Mainly, I have amateur artists in mind, rather than full-time art students. Because they don't experience the stimulating confusion of ideas that is such an important side of a full-time art course, they are sometimes inclined to develop an obsession with "technique," and to think that the method is all-important. I believe, on the contrary, that the way we look, feel, and think in relation to our subject is what matters; the actual application of the paint is conditioned by these responses, grows out of them, and has to be worked out by the individual painter according to his own needs.

The visual facts that we must become more aware of should include those that are happening on the canvas, as well as those—which we call "nature"—which lie outside it. The two categories of visual facts go together; someone who's unaware of particular relationships in his subject will almost certainly be just as unaware of possibilities in his picture as it develops. One should, perhaps, be equally and simultaneously aware of "nature" and "picture" without making too much of a distinction between them. However, for convenience, the book has been divided into three parts: Part One deals with some of the facts that our eyes see in nature; Part Two deals with color and color relationships; and Part Three deals with design and the structure of the picture.

First, then, I shall deal with the simple and objective perception of the world around us—the raw material of the figurative painter.

You'll notice that in the projects and suggestions for future work, I lay a good deal of emphasis on accuracy and the need for training the eye to observe with precision. I believe that learning to draw implies two complementary processes: first ,to look with complete objectivity and without preconceptions; and second, to see with precision and accuracy. From these processes gradually follows the ability to put things down with precision.

In talking of drawing here, by the way, I make absolutely no distinction between the act of drawing and of painting. Every mark made with a paintbrush is, to some extent, an act of drawing.

It may be argued that accuracy or precision is not the business of the painter. Of course, all artists—however "realistic"—are bound to simplify, distort, and generally take liberties; but that isn't really the point here. What's essential is that as a painter you learn how to analyze and judge subtle relationships—not so much because you'll be doing one sort of painting or another, but simply because there's no other way of training your eye to the necessary degree of sensitivity. Understanding implies precision, which is not at all the same thing as photographic accuracy.

The sheer struggle to get things right has its own value, too. Through such a struggle, a drawing attains greater intensity and concentration; in the end it is more likely to be an interesting production—in contrast with a drawing in which approximate, generalized shapes and proportions are accepted as "near enough."

This applies particularly to the early stages of your artistic development. Later on, your sensitivity to relationships will give your work its own intensity; but at first, your best chance of producing an interesting drawing or painting is probably simply to sweat over it until you can at least say, "Well, that's as near right as I can get it."

Many people may be afraid of making a precise statement because of an idea that "feeling" will evaporate, as if there were necessarily an opposition between emotion and analysis. The reverse can be true. To take an example from another

field, English lyric poetry: the intense emotion in the work of such writers as Wordsworth and Thomas Hardy is very often allied to their detailed and precise observation; they particularize, they are never merely vague. This kind of precision conveys far more feeling than a generalized image.

Among the preconceived ideas that I would like to dispel are those to do with precision and freedom, detail and breadth, realism and photography. But for the time being I will content myself with recommending that if you do the studies suggested to you in this first part, you should carry them out as completely as you can—without worrying about erasing or making a mess, and above all without worrying about style. No one need see the results except yourself. A dirty, smudged, and labored drawing that contains real observation is always to be preferred to a tidy but generalized one.

1
A SENSE OF DIRECTION

I will start by going right back to the beginning and considering some of the really fundamental facts about drawing. If the suggested subjects appear too elementary, try them just the same; you may be surprised at the deep waters they can lead you into.

How many times have you heard the phrase about not being able to draw a straight line? It is surprising how many people seem almost proud of their inability; perhaps they are implying that there is something "inartistic," something mechanical, about straight lines. Well, of course it isn't often necessary to draw a straight line—that's what rulers are for; but it *is* essential in all drawing and painting to develop an accurate sense of the *direction* of lines, which is a necessary condition of their straightness. For all lines go in one direction or another, and this is what is important about them.

If you think of a picture in the simplest terms—cutting out for the moment color, tone, even representational meaning—you're left with nothing but shapes on a two dimensional surface. These shapes can be considered as bounded by lines which are of a certain length and which run in various directions. Even curved shapes and lines can be broken down into straight sections, as in Fig. 1.

If you could get every line in a drawing from nature to go in the right direction, and to be exactly the right length, your drawing would be bound to be *accurate,* if nothing more. But it isn't only a matter of accuracy. A "sense of direction"—that is, a sensitivity to the relations between different angular directions—is essential; without it, a picture will always lack structure and rhythm.

An example of this lack of sensitivity can be found in most beginners' drawings. Usually beginners underestimate angles, making them less intense and more similar to each other than they actually are. Directions —for instance, the direction of a leaning torso or a bent limb in a life drawing—are made more vertical or horizontal; hence those rather stiff, wooden drawings that everyone begins by doing. Here, incomplete observation is allied to timidity. We can't trust our eyes enough to get over the unconscious idea that a standing figure, for example, ought to be straight up and down.

The following exercise is designed to sharpen your appreciation of angle and direction, and also to help train your eye and hand in habits of precision.

Set up any collection of long, straight objects— sticks and brooms leaning against a chair, for instance —in such a way that you get a variety of different

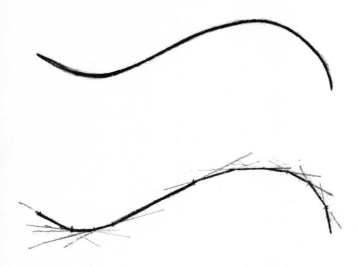

Figure 1. *A curved line broken down into straight sections.*

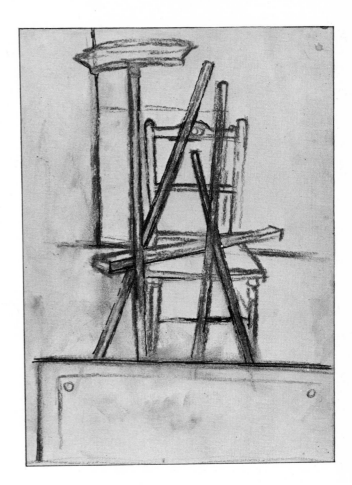

Figure 2. *This collection of long, straight forms—set up at random—gives a series of different directions. The line of the drawing board, kept exactly horizontal to serve as a guide, is seen at the bottom of the drawing.*

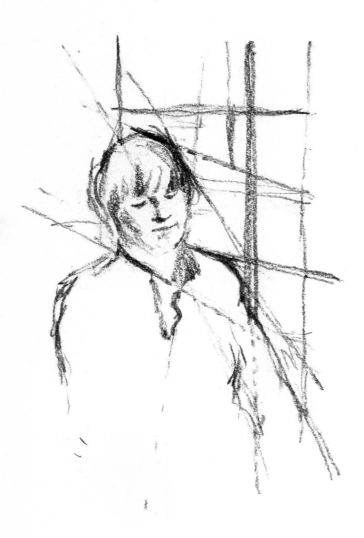

Figure 3. *Directions in a drawing can be extended beyond the form to enable the eye to check the angles against a stable vertical and horizontal.*

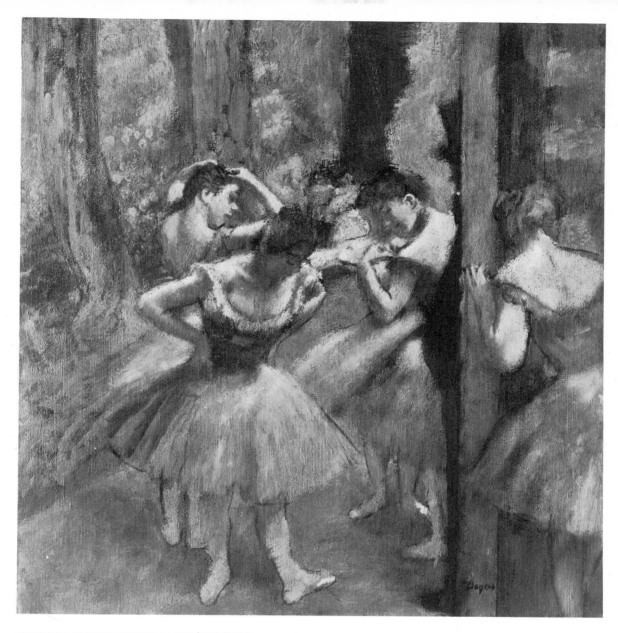

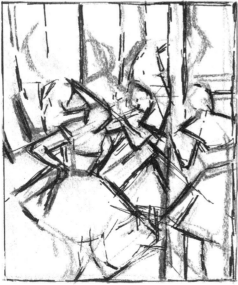

Figure 4. *Edgar Degas: Dancers, Pink and Green. Bequest of Mrs. H. O. Havemeyer, the H. O. Havemeyer Collection, The Metropolitan Museum of Art. The slanting directions of skirts, arms, feet, and so on, create very subtle thrusts and connections across the picture surface.*

Figure 5. *This diagrammatic drawing of Degas' Dancers, Pink and Green emphasizes the angular movements of the composition. For instance, notice the tilted square, or diamond, which is formed in the center of the picture: two skirts form the lower part of it; the dancer's head in the center is the top. Notice, too, the other diagonal lines which run at right angles to each other.*

angles and lines crossing one another (Fig. 2). Try to draw these directions with complete precision—no approximations, or getting it *roughly* right.

You will probably find it best to draw with a tool that allows you to make alterations easily. Charcoal is ideal. If the drawing gets dark and smudgy with continual alteration and rubbing out, white chalk can be used to help you re-define the directions. It doesn't matter at all how messy your drawing becomes; precision is not the same thing as tidiness!

It will help if you sit so that your drawing is level and square with your angle of vision. The top of the board should form an exact horizontal, as in the foreground of Fig. 2. This gives you a horizontal constant against which you can judge the slope of the lines. You'll probably be able to find a corresponding vertical in the subject, or behind it—the line of a wall or a door, for instance. This framework of vertical and horizontal is of the greatest possible assistance in judging angles. Every direction in your subject can be related to them; if necessary, the lines can be continued beyond the form so that they meet these horizontals and verticals and the resulting angle can be examined (Fig. 3). As you can see, this works in any sort of drawing.

Don't worry about perspective, or whether the objects come in front of or behind others. Try to see the directions as if they were on a flat surface. If the drawing is accurate, the perspective will look after itself.

Don't just make a long, sweeping line for each direction; a line so drawn is likely to be imprecise. Draw slowly; as you come to each intersection, where one line crosses another, try to estimate the angle at which they cross. Draw the line, in fact, not in one stroke, but from point to point where it meets other lines. In this way, you judge relationships and see the group of lines as a whole, rather than as separate pieces which you deal with one at a time.

The position of the point at which a line crosses another is also important. If the angles are right, the proportions should also work out in the end!

Degas was an artist with a very highly developed sense of the way that one direction works against another. In a picture like *Dancers, Pink and Green* (Fig. 4), the apparently casual grouping conceals the most complex and subtle play of one oblique direction against another. Over and over again, the direction of an arm or the side of a skirt, if continued, forms a right angle or a parallel with some other shape. The diagram (Fig. 5) shows, in simplified form, something of the complexity of these directions.

2

SPOTS
AND
PLACING

Another basic factor in drawing and painting is the placing of points, or units, in relation to others. Any picture you can think of is made up of shapes, connected or separate, placed across the picture surface in relationship to each other and to the rectangle (the paper or canvas) bounding them.

In the first section, I discussed the judgment of direction. You found in the exercise that if the angles were accurate, the resulting intersection of the lines would occur in the right places. In that project, then, you were not so much estimating distances, as directions.

As soon as you begin to relate one form to another form which is separated from it, you have to consider distances and gaps. This happens as soon as one mark is put down in the rectangle of the picture.

If I put a spot, A, anywhere in a rectangle (as in Fig. 6), I am immediately setting up a simple set of relationships. The spot is a particular distance away from each of the edges and from the corner. These distances can be indicated by lines AB, AC, and so on. The inclination of the imaginary line AC is at a particular angle to the vertical. You could think of these lines as the mooring lines of a boat in a harbor.

As soon as you place another spot, X, in the rectangle, you're obviously setting up a fresh set of relationships: AX is a certain length that runs at a particular angle (Fig. 7).

This kind of simple relationship occurs, to a more complex degree, in any subject one can think of. In a portrait, for example, the corner of the mouth has to be placed precisely in relation to the nose, or the eye drawn in relation to the ear (Fig 8). In a still life, the distance between an apple and a plate can be calculated as precisely as the distance between any other two spots.

Here's a test of your ability to relate disconnected units, an exercise that simplifies the problem to its bare essentials. Take a board and a dozen or so pushpins or thumbtacks. Stick the pins in at random, some clustered together, and some at longer intervals (Fig. 9). Set up the board vertically in front of you and try to draw the positions of the pins as accurately as you can. The distances between the pins, and the angles of the imaginary lines linking them, should be worked out without any approximation.

The best way to begin a study of this kind is to relate two or three points, and then to work outward until you come to the edge of the board, as indicated in Fig. 10, the edge of the board must be drawn as an essential part of the measuring process It's better not

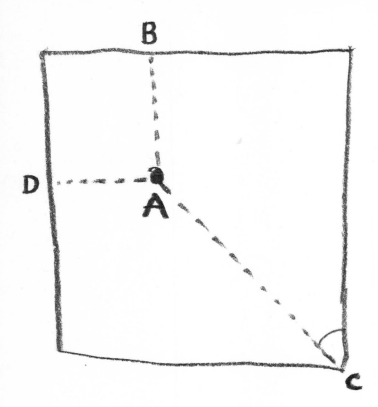

Figure 6. *One mark on a rectangle immediately sets up a set of relationships.*

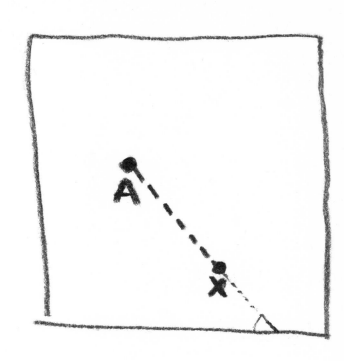

Figure 7. *Two marks on a rectangle set up a new relationship and imply direction as well.*

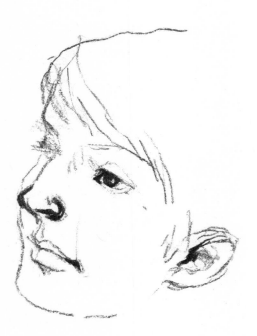

Figure 8. *Note the relationship between important points in drawing a head.*

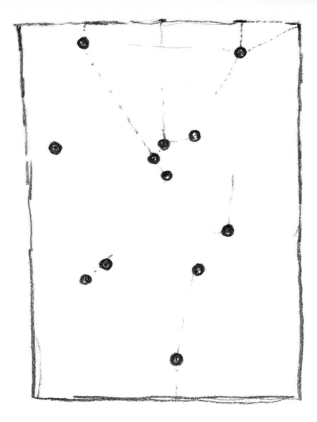

Figure 9. *Push-pins or thumbtacks are placed at random on a board.*

Figure 10. *Start a drawing by relating a group of points (made with push-pins or thumbtacks) to each other and to the outer edges of the board, working from the inside out.*

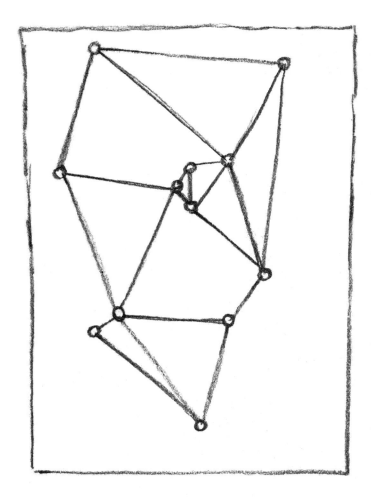

Figure 11. *Push-pins or thumbtacks are joined with string or rubber bands to form shapes (left).*

Figure 12. *Above, the board with push-pins or thumbtacks is drawn in perspective. Vertical "plumbing" must be used in this case, and the foreshortened shape of the board can be arrived at by observation in relation to the inner shapes, rather than on preconceived ideas about converging lines. To do this, look at one point in relation to another directly above or below it; hold up your pencil to make a vertical so that you will be able to judge their exact relative positions. This procedure is known as "plumbing."*

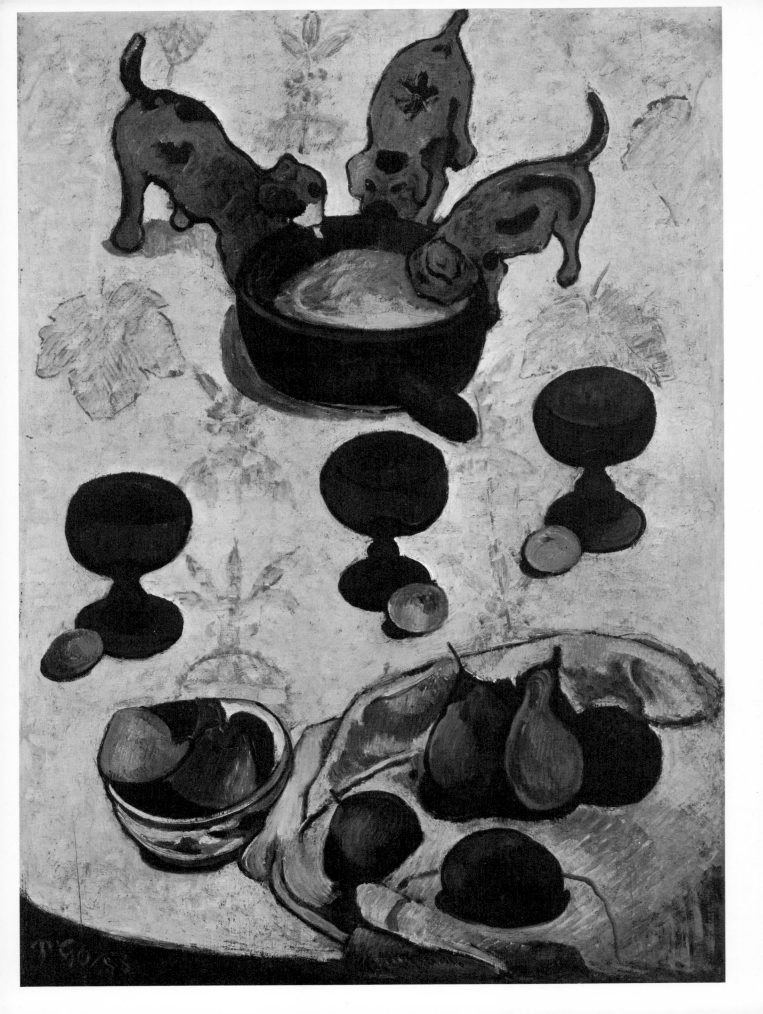

to make a guess at the whole shape at the beginning; add it piece by piece, along with the spots, through a series of observations. Don't be afraid of making constant alterations and readjustments of position.

Next stage: join the pins with thread or rubber bands. Now you have a pattern of linear connections, forming shapes. Do the same thing with lines on your drawing, and see if the shapes look the same (Fig. 11). You'll see how much easier it is to relate two separate points if they are connected. If three points join to form a triangle, you can see at once if you have drawn them inaccurately because the shape of your triangle will be markedly different from the·one on the board. This connecting triangle, or any other shape, can be visualized as you draw the isolated units.

You can now go on a stage further by putting the board down on a table so that you are looking at it in perspective (Fig. 12). Repeat the process, drawing the push-pins in exactly the same way as before. Don't bother about the fact that some points are now further from you than others; draw them as if they were on the same plane—on a vertical sheet of glass, so to speak. In other words, measure to see if one point is vertically *above* another, regardless of whether it is actually further *behind* it. Develop the shape of the board in the same way. You'll find that the perspective of the board will develop out of your observations of distances between the pins and the edge of the board. You will, in fact, make a perspective drawing without thinking about it—by working, so to speak, from the inside outward.

From this point, it is a short step to tackling a simple still life drawing in precisely the same way. Instead of points, you are now dealing with objects on a flat plane seen in perspective; but the problem is the same. You could use any casual grouping of objects, such as a table before a meal has been cleared away.

Gauguin's *Still Life with Three Puppies* (Fig. 13) exemplifies a picture built up essentially on the basis of separate units on a flat surface (though the lower part offers a more conventional still life arrangement in which the units are connected by other forms, such as the cloth). But whether connected or isolated, these units are subtly related. This picture was almost certainly "made up" out of separately observed elements; the puppies and the still life were not carefully arranged and the distances between them measured. However, the placing and the relationships between the shapes were calculated with a great deal of certainty and precision.

Figure 13. *Paul Gauguin:* Still Life with Three Puppies. *Mrs. Simon Guggenheim Fund, The Museum of Modern Art. This picture is composed of comparatively separate, detached units scattered over the picture surface. The intervals, or gaps, between them have been carefully taken into consideration even though the painting was presumably not "done from life."*

3

MATCHSTICKS

Here is one more elementary drawing for you to try. It combines observation of direction and angle with observation of distance and space.

Scatter a handful of matches on a piece of paper or board (Fig. 14). When making your drawing, consider each end of a match as equivalent to one of the spots in the previous exercise.

This exercise can be developed further by seeing what will happen if you extend each direction, or line, until it meets the edge (Fig. 15). This will prove just one point, nevertheless quite an important point: that separate shapes, even if they are a long way apart, still affect one another. An angle such as *AB* runs at right angles to *XY*, which is on the other side of the drawing, and to some extent links up with it. You'll find a number of these connections in a complicated picture like Degas' *Dancers, Pink and Green* (Fig. 4).

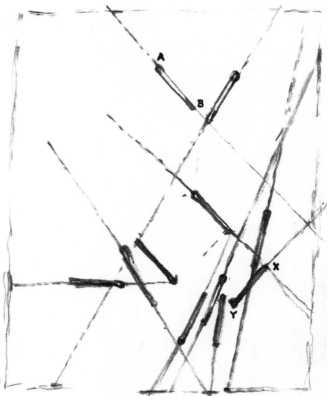

Figure 14. *Matches are scattered at random on a board: make your judgments of distance and direction as precisely as possible.*

Figure 15. *The relationship of the angles made by the scattered matches is emphasized by continuing each direction until it meets the edge of the board.*

4

CURVED
SHAPES

So far we've been thinking in terms of straight shapes and of points. But we could, of course, tackle curved shapes and lines in the same way.

As I said before, curves can often be simplified into a series of straight tangents (Fig. 16). The only reason to do this is to clarify the character of the curve. Don't make everything rectangular for its own sake!

It may help if we consider for a moment some varieties of curves. First, let's look at a curve which could be labeled "geometrical"—a mechanical arc that can be drawn with a pair of compasses. This, of all curves, is the one most difficult to simplify into straight sections, for the simple reason that its curvature is the same throughout (Fig. 17).

The second type of curve is found in practically all living forms: plants, animals, and human beings. Call it, then, the "living curve." Essentially, the living curve is made up of straight sections contrasting with tight curves (Fig. 18). The most perfect example of this type of curve is the logarithmic curve (Fig. 19), which is a mysterious and beautiful example of the fusion of natural form and mathematics (it can also be produced mathematically). As you can see, the logarithmic curve is composed of a curve gradually tightening towards infinity. It is related to another strange phenomenon, the golden section ratio, a concept which will crop up later in this book.

Finally, you should be aware of the limp, or non-organic curve, which you can see in a soft piece of string dropped on a flat surface (Fig. 20). A non-organic curve may contain straight, kinked, and curved sections occurring in a random way.

Take this last example as the starting point of your next exercise. Drop a short piece of string onto a piece of paper placed in front of you, and draw it from above. Note especially the interaction between straight and curved sections, and study the character of the spaces left in between the loops. Now do the same thing with the paper and string at an angle to your eye, so that you're drawing it in perspective, as you did with the push-pins. Notice how some curves are flattened, others made more intense (Fig. 21).

To study the character of living curves, no organic form is better to draw than leaves. Almost any plant will do for this purpose. Keep the problem as simple as you can; three or four leaves will be quite enough. The plant must stand upright so that its leaves spring in their natural way. Some leaves will be foreshortened or viewed from a "difficult" angle. Don't be afraid of this challenge. See Fig. 22 for an example of a more complex plant drawing carried out in this way.

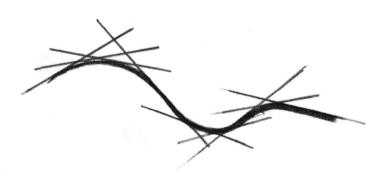

Figure 16. *A curved line can be considered as a series of straight tangents.*

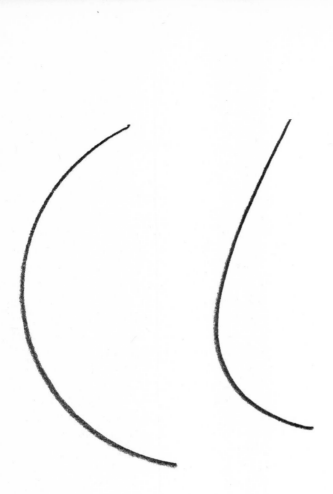

Figure 17. *A geometrical curve (left) made with a pair of compasses.*

Figure 18. *An organic, or living, curve (right) is similar to those found in plant forms.*

Figure 20. *A limp, non-organic curve can be formed by dropping a piece of string.*

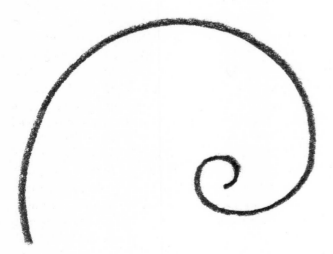

Figure 19. *A logarithmic curve can continue on to infinity.*

Figure 21. *Here is the piece of string that we dropped in Fig. 20 seen in perspective.*

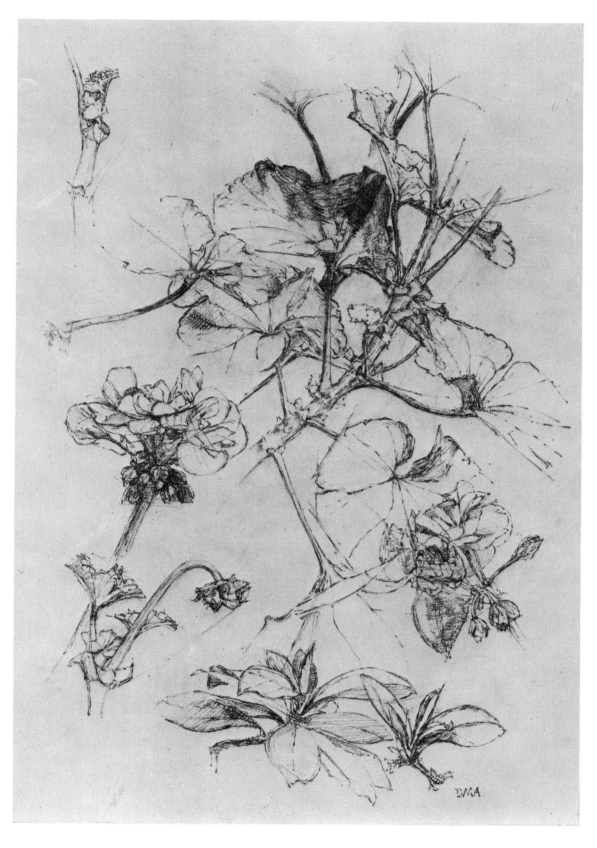

Figure 22. *In this page of plant studies by Diana Armfield, notice the springy quality of the line and the way that gaps, or negative shapes, are observed as closely as the forms.*

5
PLUMBING

In making drawings of lines and spots, you tried to place them accurately and at the right angle. You probably found out the importance of checking against a perpendicular to see where points relate to others below or above them.

Point A, for instance, can be positioned in relation to point B by dropping a perpendicular and estimating its distance away from B on the base line (Fig. 23). It is, actually, about half as far away as the height of A.

It is much easier to get the "lean" of the man in Fig. 24 if we think that his cigarette, if he dropped it out of his mouth, would fall on the ground well away from his feet—between his feet and the wall, in fact.

In the drawing of the girl in a chair (Fig. 25), a line dropped from her eye exactly cuts the wrist. Most beginners, as I mentioned before, underestimate the angle of tilted forms, and these three simple illustrations show the value of checking to verify angles.

The foregoing is what I meant by calling this section "plumbing." As you get more confident, you plumb almost unconsciously. At this stage, I suggest that you not only *think* the perpendicular (or horizontal, for that matter) but actually *draw* it in lightly. You may notice that I've done this in a number of drawings in this book.

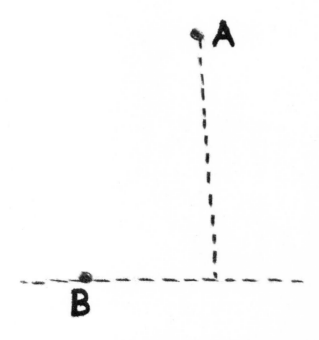

Figure 23. *Two points can be related by means of a vertical and a horizontal line.*

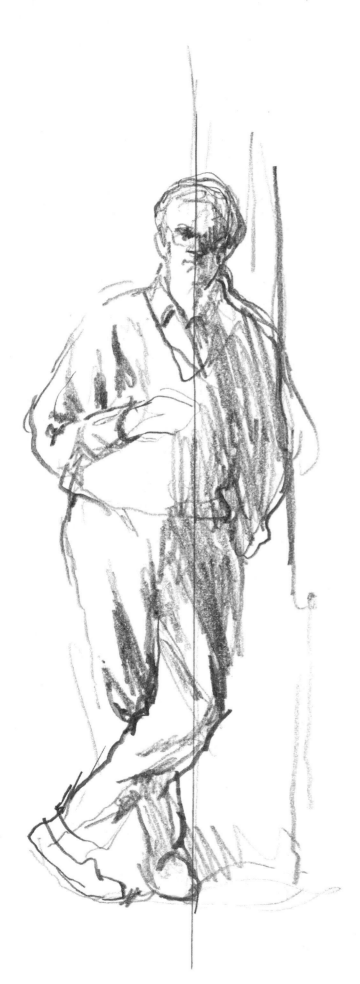

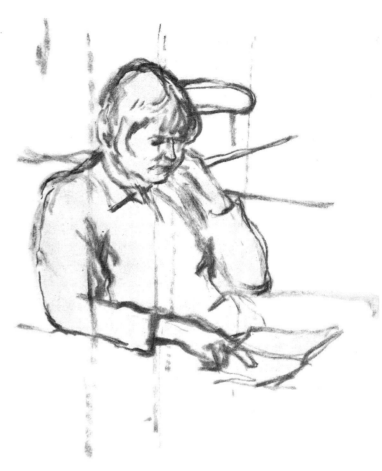

Figure 25. *Notice the way the wrist happens to be placed exactly under the eye; this helps to relate the arm to the head.*

Figure 24. *A vertical line dropped from any point on this drawing will cut through some lower part.*

6
NEGATIVE
SHAPES

The term "negative shapes" is used to describe areas in the background of a painting or drawing which come between and around the actual solid forms in the picture. Although these "blank" spaces are often ignored, they are actually of the greatest importance. To develop an awareness of negative shapes is to understand that every picture, whatever its subject, is composed of a certain disposition of colored or tonal shapes across the flat surface of the paper or canvas; and that all these shapes are important, whether they represent objects or background. Moreover, we are not likely to have any strong preconceived ideas about what negative shapes look like or how to draw them. They must be regarded as purely abstract shapes, and drawn accurately by sheer observation.

One of the major difficulties about drawing or painting any familiar subject—a human being, an apple, or a landscape—is that we have unconscious preconceived ideas about its shape. These ideas about how things "should look" often prevent us from seeing with an innocent eye. One of the purposes of this book is to try to break through such preconceptions.

Because we know (or think we know) something about the usual relation of a head to a shoulder, we may not look quite as hard at the angle and shape that they make together. But by also observing the shapes that are made by the bits of wall or background that the head and shoulder cut out, by isolating them and drawing them as carefully as the model's nose, they can be used to check the accuracy of the way we have drawn the tilt of the head. In Fig. 26, these shapes, which I have marked with an X, have no preconceived quality. They are just shapes that can be studied with complete objectivity.

Nearly all paintings—and particularly those which depend on light and dark silhouette—to some extent make use of negative shapes. In this detail from a painting by Vermeer (Fig. 27), the light area of the wall cut by the figure can be "read" almost as if it were an individual shape like the one in Fig. 28. I'm sure that Vermeer was very conscious of this area, as well as the actual profile of the girl's dress.

Later artists, such as Degas, Gauguin, and Sickert, were particularly sensitive to the quality of background shapes. The Sickert drawing reproduced in Fig. 29 exemplifies this sensitivity as well as many of the other points I've made about drawing.

Possibly, many people are rather afraid of overemphasizing negative shapes because of the idea that the background must be kept subordinate; that otherwise it will come forward, command too much atten-

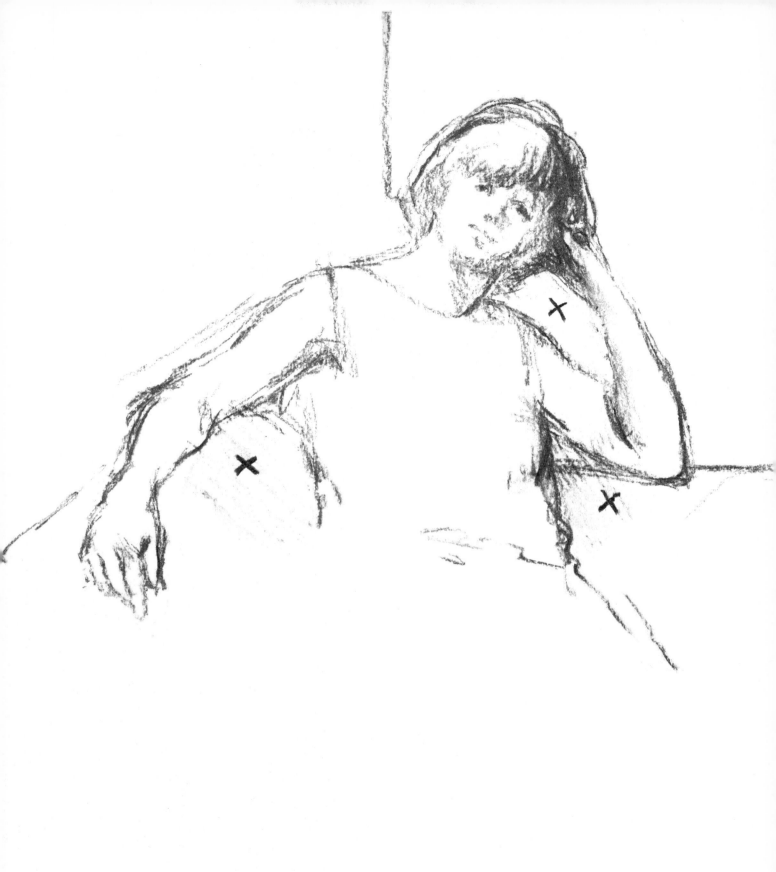

Figure 26. *The space between the head and the shoulder makes a shape against which you can check the accuracy of your drawing. An "abstract" shape like this can be seen with no preconceptions about what it should look like.*

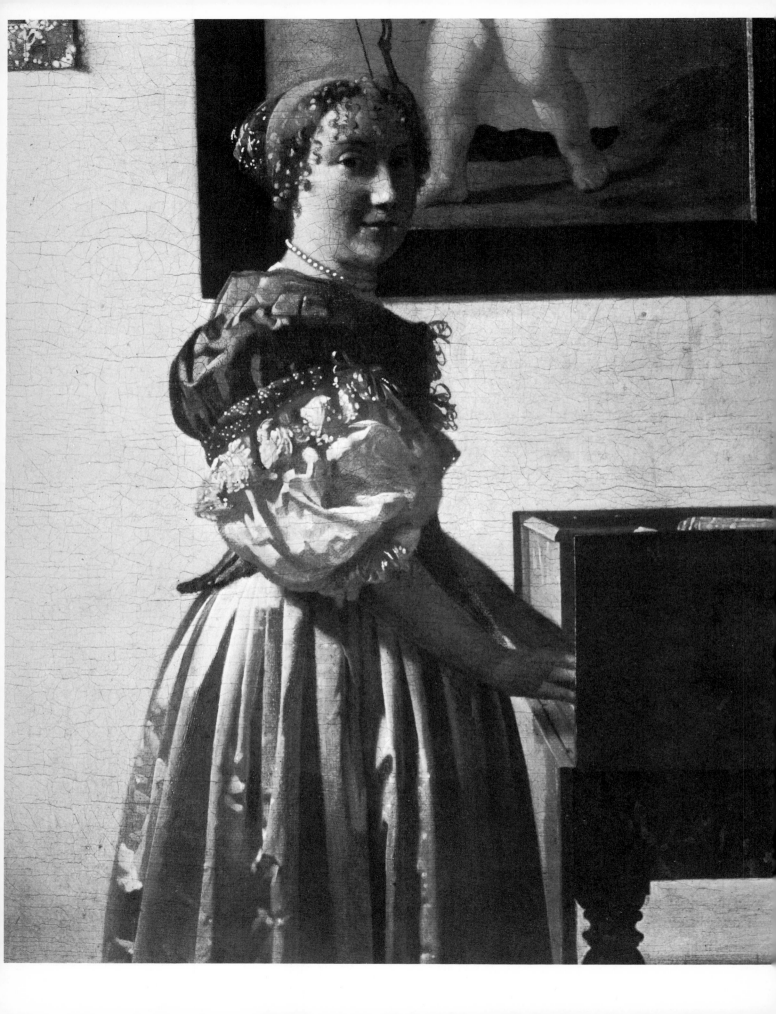

Figure 27. *Jan Vermeer: detail from* A Lady at the Virginals. *National Gallery, London. The light area of the wall, against which the figure is silhouetted, is full of interest as an abstract shape.*

Figure 28. *Here is the area of wall seen in Fig. 27 isolated and drawn separately.*

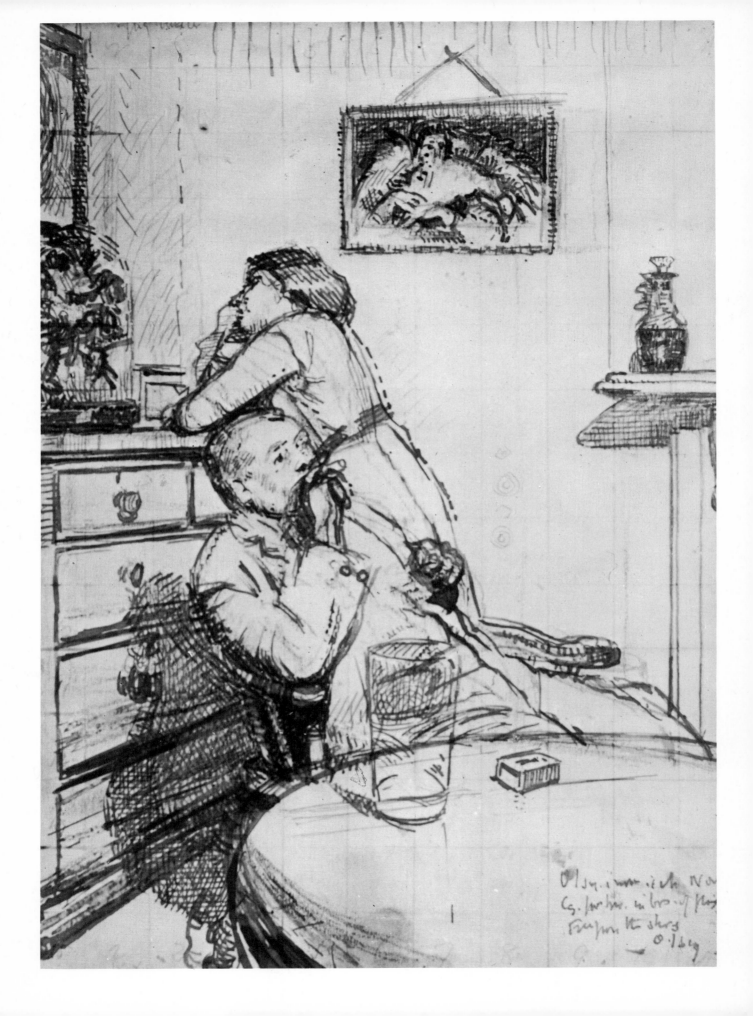

tion, and swamp the main elements of the subject. In practice, there is seldom any need to worry about this. Inaccurate tone or color is much more likely to be the culprit when a background is fussy or over-assertive. Accurately observed shapes and precise drawing tend to keep forms securely in their right place.

Get into the habit of concentrating just as intensely on the shape of negative spaces and background areas as on the observation of the solid forms, and use them to check the precision of your drawing.

As an experiment, make some drawings in which only the negative spaces are rendered, rather than the objects themselves (Fig. 30). The exercise will be more telling if you put down these spaces in black to make them more obvious. By drawing only the spaces and by leaving the objects blank (making them, in fact, "positive" rather than "negative") you will clearly see how an object can be built up and defined by means of its surroundings.

Figure 30. *By making the background spaces solid, we can emphasize their importance in establishing the whole form of the composition.*

Figure 29. *Walter Richard Sickert: drawing for* Ennui. *Ashmolean Museum, Oxford. Sickert's drawings, such as this one, are very often done with a painting in mind. The shapes of the "spaces between" and of the background areas are closely observed in relation to the figures.*

7

POINT-TO-POINT

Figure 31. *The bottle is drawn first, then the bowl.*

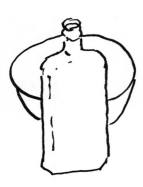

Figure 32. *Bottle and bowl are drawn together.*

I use the phrase "point-to-point" to describe a certain attitude to drawing which can be summed up like this: suppose I want to draw on the table in front of me a bottle with a bowl in front of it; I can either put the bottle in first and then add the bowl (Fig. 31), or I can draw both the bottle and bowl together (Fig. 32). If I choose the latter method, I move my pencil away from the bottle where the bowl cuts against it; then, before I go any further, put in—even if tentatively—a segment of the bowl. This procedure is an attempt to see, and thus to draw, the entire form as one unit, with the foreground and background indissolubly wedded. This approach is intimately connected with painting, where we see objects as related silhouettes. As an approach to drawing, point-to-point is no better and no worse than any other. It is very useful, though, to train the eye to see relationships, rather than separate objects.

The way to set about this kind of drawing is generally to start at any place that interests you and then to work outward, jumping from one point to another adjacent one. The whole drawing gradually builds itself up from an accumulation of small jumps and distances, marks and touches, rather than from a series of long contours.

The main limitation in point-to-point drawing is that it can encourage a certain unselective, map-drawing quality, a mapping of shapes. But against this drawback is a big advantage: with this technique, almost anyone who is prepared to look hard can produce a useful drawing. It is simply a matter of putting into practice, when faced with the complexity of a figure or a landscape, the very simple approach to directions and placing of points that we studied at the beginning of this part.

In the first stage of a drawing of a woman in a room (Fig. 33), you can see how I started at the most obvious and natural place—the head. It seems sensible to begin where one's eyes naturally go first. Sickert called this tendency the "eye-catch" (this sort of drawing derives very much from Sickert and Whistler). The idea is to use the eye-catch point as the center from which to make a series of reconnaissances into the surrounding areas (Fig. 34). From the top of the head, it's a short jump across to the corner of the tilted eyelid, or down to the shoulder through the back of the chair. One point can be "plotted" in relation to several other points; no straight line or direction should be placed without relating its angle to a vertical or a horizontal.

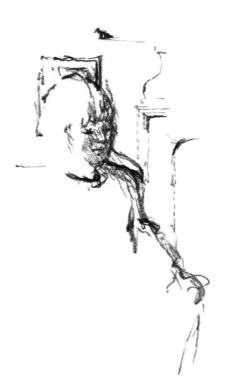

Figure 33. *Starting a drawing by working outward from any given point.*

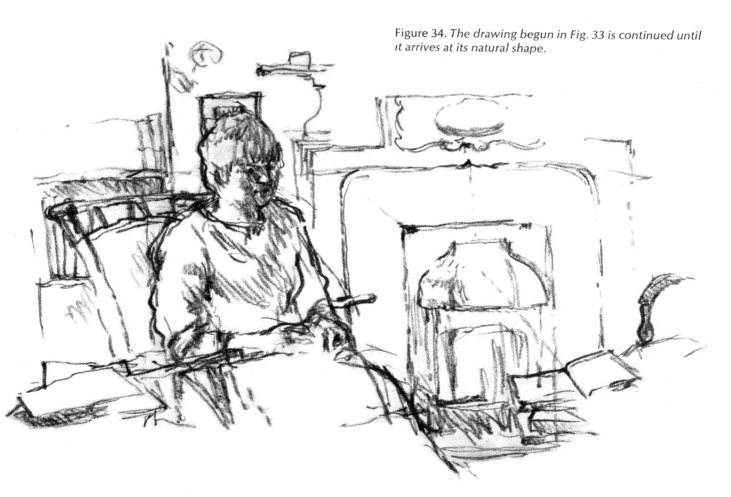

Figure 34. *The drawing begun in Fig. 33 is continued until it arrives at its natural shape.*

Figure 35. *In this page from a sketchbook, the shapes are done rapidly, almost instinctively, and brief notations help me remember the scene later on.*

8
DIFFERENCE
OF SCALE

Stretch your two hands out in front of you, one at arm's length, the other at half the distance from the eye. Keep a fairly large gap between them. Though they won't appear very different in size, in fact the image of the further hand is exactly half the size of the hand nearer you. If you move one of your hands across the other, keeping it the same distance from your eye, you'll be able to perceive this big difference in scale.

The image of an object halves in size with each doubling of the distance of the object from the eye. However, it doesn't appear to shrink this much, for the brain has a curious built-in capacity to make allowances for differences in scale. This capacity, known as "size constancy," explains why we often find the relative sizes of things in photographs unconvincing, when actually they are quite accurate. Everybody is familiar with the way that impressive mountains seem to shrink to molehills when they're photographed. This is not, as is often supposed, due to some curious trick of the camera's lens. It happens simply because we know how big the mountains are and make this allowance when we look at them.

To be aware of this fact doesn't mean, of course, that we should always feel bound to use a "correct" scale in painting. Cézanne, in his painting of *La Montagne St. Victoire* (Fig. 36), almost certainly emphasized the height of the mountain for the purpose of his design. If you like, you could say that he was carrying the principle of size constancy a stage further. Rembrandt, when painting a group of figures (Fig. 37), would modify scale in just the opposite way round; consciously or not, he would make all the heads approximately the same size, whether they were in the foreground or the background.

But whether we magnify or diminish differences of scale, size constancy helps us to become aware of the tricks our eyes can play; or rather, the tricks the brain can play in modifying the messages that the eyes pass on.

Look at people in any crowded space—a train, a football stadium, or a station platform—and try to estimate the differences in scale caused by their distance away from you. Better still, have two people sit in an ordinary room, one at a distance of three or four feet from you, and the other on the far side of the room. Make a drawing, with the figures some distance apart (Fig. 38). Now you move so that your models' heads are almost overlapping (Fig. 39). You may well find that the farther head is much smaller than you had thought when you made the first drawing. Very

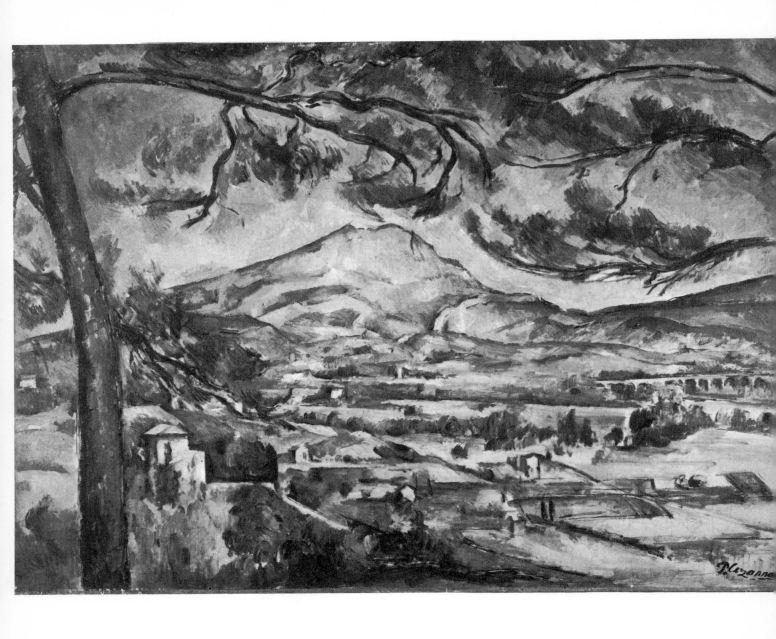

Figure 36. *Paul Cézanne:* La Montagne St. Victoire. *Courtauld Collection, University of London. The height of the mountain has probably been considerably exaggerated for the purpose of the design.*

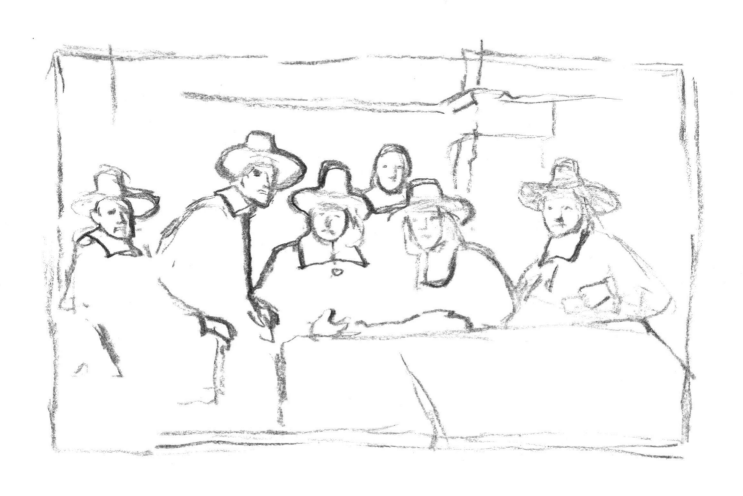

Figure 37. *A drawing after Rembrandt's* The Syndics. *The scale of all the heads is made roughly the same for the sake of unity. Notice also the beautiful negative shape between the standing figure and the seated man on his right.*

likely, you unconsciously increased its size. In the second drawing, where the heads are closer together and can be compared more easily, you probably observed more accurately the relative scale if you have really related one shape to another.

This is one reason why it always helps to relate the object that you are drawing to its surroundings. If you use the objects in the room around the two models as part of the drawing, the shapes that, for example, the furniture makes between them gives a clue to their scale and makes it easier to relate them.

It's not always necessary to use such extreme differences of scale; in fact, you may endanger the consistency of the whole picture—it may even look too odd to be true. A figure in the background can appear merely dwarfish instead of distant. On the other hand, as you can see in many pictures by Edgar Degas, or in the painting by Edvard Munch shown in Fig. 40, extreme differences of scale can define space very clearly, besides providing visual surprises. It all depends on what you're trying to do.

Figure 38. *The difference in scale between the two heads is probably greater than it appears to be at first.*

Figure 39. *The difference in size of the two heads in Fig. 38 can be seen more easily when they are seen closer together.*

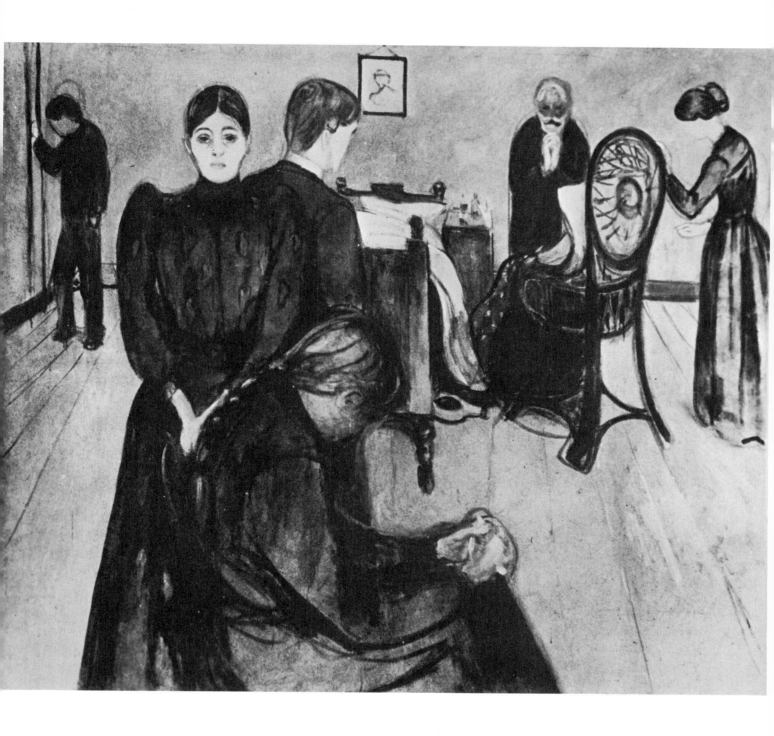

Figure 40. *Edvard Munch:* The Death Chamber. *Munch Museum, Oslo. The sudden change of scale between foreground and background does two things: it establishes the space in the room very intensely, and it causes a large variety of silhouetted shapes. It's easy to see in this picture how Munch has used an extreme difference in scale for expressive purposes.*

9

PLANES AND CHANGES OF PLANE

All solid forms are composed of planes. We are largely made aware of the character of a form by the way that the light falls on these planes. Even a curved form can be thought of as an infinite succession of tiny planes (Fig. 41).

The "change of plane" occurs where one plane meets another. The tone (and color as well) is likely to change at this point, according to the angle that the plane makes to the direction of the light. Therefore, the change of plane—and particularly the exact place where a major shift from light to shadow occurs —is crucial in both drawing and painting in order to imply solidity or a three dimensional quality.

A change of plane may have a variety of appearances. It can be sharp, curved, changing from sharp to curved, or broken and irregular (Fig. 42). The type of change depends very much on the material structure of the object. Crystalline substances like coal have very clear, angular changes. Some fabrics make sharper folds than others; a fold in any fabric, however, tends to change along its length from sharp to rounded. Living forms such as animals or people contain a tremendous variety of changes of plane. Even in one small area, such as a limb or shoulder, the form can change from full, smooth curves to sharp, bony structure. Life drawing is at first difficult because you have to think of so many things at once when you draw a figure. For this reason, perhaps it is a good idea to approach the same drawing problems in a simpler way.

Take a sheet of white paper, and crumple it in your hands. You'll have no fixed ideas about its appearance and you can study the paper at close quarters. Throw it down on the table where a fairly strong light shines on it, and make a drawing that concentrates entirely on the changes of plane (Fig. 43). Pay particular attention to whatever happens along the actual division between one plane and another; see if it alters from sharp to gradual, and see how it compares with other changes. There's likely to be quite a difference between parts of the form with sudden, complex, or violent changes in some areas, and less dramatic shifts in others. See if you can make distinctions in your drawing to correspond with these differences of tension.

The one thing that doesn't matter at all in a drawing of this sort is how you do it. Many people feel worried, as soon as the words "shading" or "modeling" come up, about whether they should do it this way or that. This is the wrong approach. Don't think about contour and shading as two separate acts, one

a little more difficult than the other. Instead, concentrate on the turning of the planes (the contour is only where the form stops). Try to visualize it almost as if you were a fly crawling over it and doing a bit of mountaineering, and very soon you will stop worrying about which way lines should go. Any scribble or mark is as good as another, if it does what it has to do.

The drawing reproduced here (Fig. 44) makes no particular distinction between interior modeling (changes of plane) and contours or outlines; the marks are unpremeditated and grow naturally out of a response to the alternating complexity and simplicity of the form.

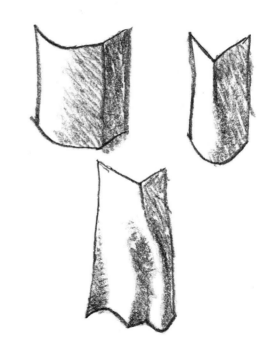

Figure 42. *This drawing illustrates different kinds of change of plane. The exact place where light changes to dark tells you more about the form than any other part of the modeling.*

Figure 41. *A curved plane can be considered as composed of a succession of small, flat planes, just as a curved line can be considered as constructed from straight lines.*

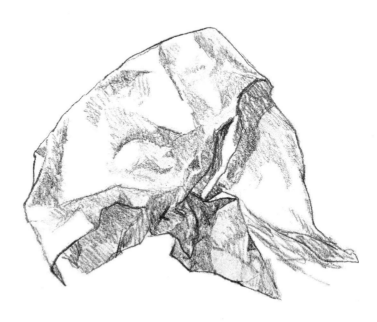

Figure 43. *This drawing of crumpled paper shows varying changes of plane.*

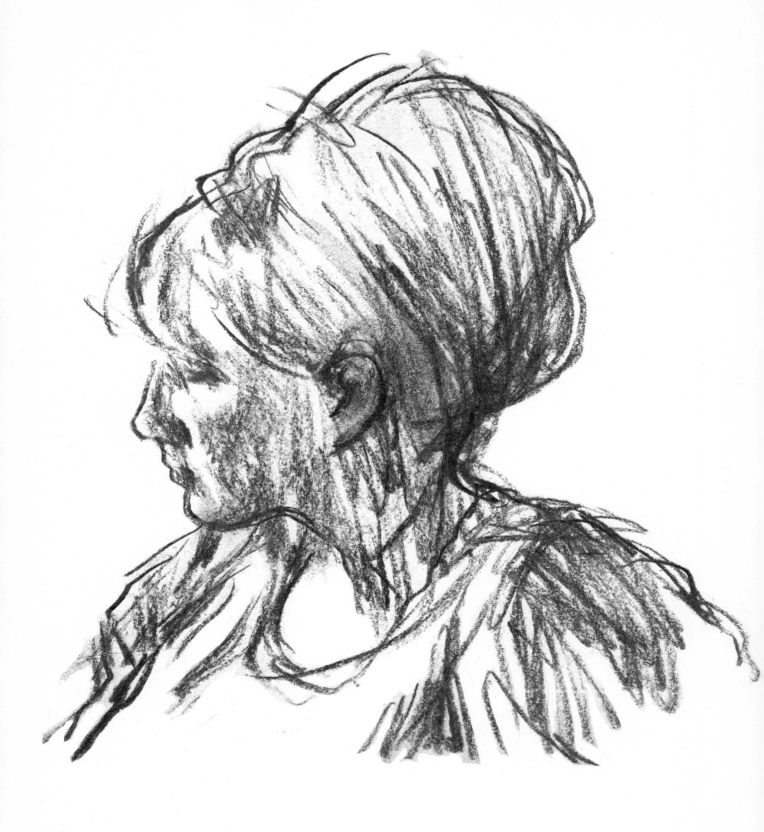

Figure 44. *The marks used to establish the form in this drawing of a girl's head make no particular distinction between "contour" and "modeling."*

10
TONE AND MODELING

In the last section, the word "modeling" came up. The two terms "tone" and "modeling" often cause some confusion—and not only among beginners. One often sees otherwise very competent paintings which suffer from a lack of unity due to a misunderstanding of the effect that tone has on modeling.

Let us define tone as the relative darkness or lightness of any part of a painting; and modeling as the change of tone caused by the light moving across different planes. Modeling, then, is a relationship of tones. Color also comes into play in modeling but for the moment we'll leave that out.

Any object, obviously, can be in itself light or dark. A face is light in tone, a businessman's suit is dark. Given a fixed source and amount of light, the change of tone caused by modeling—that is to say, the difference between the light side and the dark side—will be greater in the light object than in the dark one. Though this observation sounds obvious, beginners often don't appreciate it. To confirm my point, try this simple experiment.

Take two pieces of paper, one light in tone and one dark. Fold them at right angles, identically, and stand them in a side light, as in Fig. 45. If, in each case, you compare the tone on the light side with that on the dark side, you'll see that the tonal difference is greater on the piece of white paper. You can analyze the difference by comparing it with a graduated tone scale (Fig. 46). In this example, the contrast in tone from one plane to another on the white paper is roughly from 1 to 5, or four steps; and on the dark paper, from 10 to 12, or only two steps.

Let's consider how this principle affects more complex subjects, a portrait (Color Plate 1) and a simple still life drawing (Fig. 47). Notice in the portrait how the modeling in the three main areas—face, hair, and clothes—is affected differently by the local tone. The face is strongly influenced, the dark clothes less so. This welcome variety and breadth can easily be lost is everything is modeled with equal force.

Fig. 47 illustrates a drawing in which local tone is ignored and in which everything is regarded as having simply a dark and a light side. Next to it is a small sketch in which I have tried to show something of the actual tone of the same group (Fig. 48). This disregard for local tone in a drawing used to be recommended by some teachers, the idea being that tone is strictly an attribute of painting and has nothing to do with drawing. When drawing according to this philosophy, one should ignore the fact that different parts of the subject are light or dark in themselves and use tone

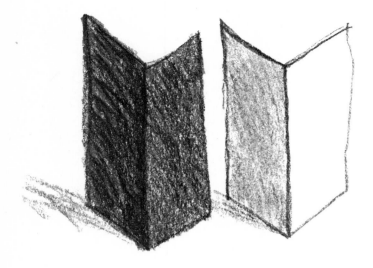

Figure 45. *Is the difference between light and dark the same in both these pieces of folded paper?*

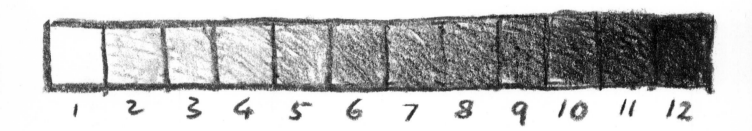

Figure 46. *A tone scale gradating from white to black.*

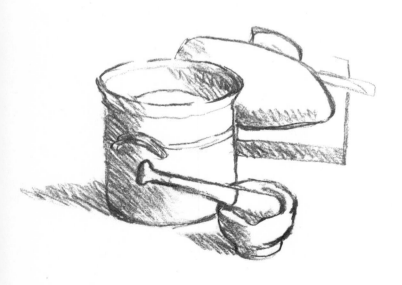

Figure 47. *Tone can be used purely for modeling, ignoring the actual tone of objects.*

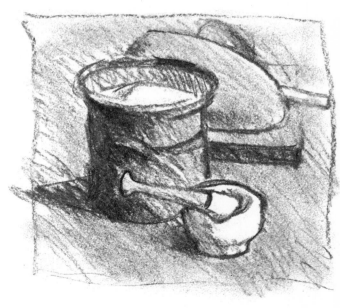

Figure 48. *Here is the actual tone of the group of objects shown in Fig. 47.*

only to show structure. This theory may be tenable when one is making a life study, such as the one shown in Fig. 49, but it obviously has little to do with painting.

Even when applied to drawing, tone used only to build structure becomes schematic and abstracted, rather than observed. A study, which essentially should be a fresh response to the objects or forms seen, becomes instead something of an intellectual exercise.

The following idea for a simple painting can help you grasp the concept of close tonal relations and their groupings: collect and arrange some dark objects on a dark piece of cloth or paper; next to them place some light objects against a light ground. Notice very carefully the relative tone changes in both halves, and particularly observe the differences or similarities between the lightest plane on the dark side, and the darkest plane on the light side. The set-up can be further modified by placing one light object on the dark side, and *vice versa* (Fig. 50). This study can be carried out in monochrome.

The old masters—and particularly the Venetians—often played off large areas of simple, unmodulated dark against complex and closely modeled light shapes. The dark areas were even simplified into flat masses. Fig. 51, based on a passage from one of Titian's greatest paintings, *The Entombment,* shows how this use of tone operates. This rough sketch tries to give you some idea of the way that Titian has confined all the rich and complicated small modulations into the light flesh and the drapery.

The scale of tones that I mentioned before (Fig. 46) can be compared to a piano keyboard. If we think of it in this way, then parts of the Titian painting are played in a high register, perhaps from 1 to 4, while other areas remain completely within a lower range, say from 5 to 9.

The *lightest* part of a dark, low-register passage may well still be lower in tone than the *darkest* part of a light passage. This is rather important, because a very common fault is to confuse these relations of tone, so that "jumpy" lights in the darker parts break up the continuity of the tone pattern and grouping. This will almost certainly occur if an artist concentrates, while painting, on one part of the picture at the expense of the surrounding areas. Let your eye move about freely from, say, a dark patch on one side

Figure 49. *In this life drawing, tone is used as modeling. Note how the hair is treated in the same way as the flesh.*

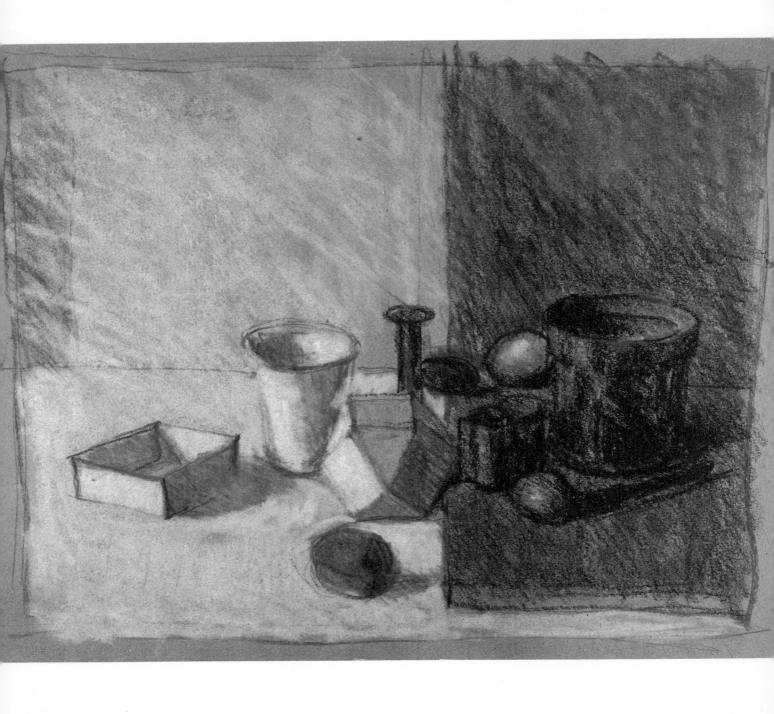

Figure 50. *This still life group is arranged as a light area and a dark one. The darkest parts of the light side may be no darker than the lightest parts of the dark side.*

of the field to a similar one on the opposite side. Try to estimate whether the tones are exactly the same, or, if not, what the difference is between them. In the same way, take two patches in your picture whose colors sharply contrast. Is the tone of one lighter or darker than the tone of the other?

Especially watch what happens when a light area falls in the middle of a dark passage, or *vice versa*. It is very easy to allow these lights and darks to jump, because one tends to overestimate their difference in relation to their surroundings.

I must admit that this sort of intensive observation of tonal relations may seem anachronistic to many readers. Whereas it used to be stressed in art teaching, nowadays tone is almost ignored. Instead, color relationships are emphasized. But I find it difficult to separate the two. Every colored area also has a tonal value. An eye which is accustomed to searching out subtle tonal differences will probably be more sensitive to color subtleties as well.

Figure 51. *This drawing after a detail of Titian's* Entombment *shows the massing of tonal areas.*

11

ON NOT TAKING THINGS FOR GRANTED

Japanese painters have always guarded themselves against the common tendency to take visual appearances for granted. They are said to have made a practice of bending over and looking at a landscape upside-down between their legs in order to see it quite freshly. Perhaps they were better at gymnastics than we are, and better able to appreciate the upside-down scene without the interference of spots or a red mist in front of the eyes.

If you can look between your legs without physical danger, you'll certainly get a new view of reality. Similarly, turning a painting that you are working on upside-down often enables you to see its abstract qualities afresh. You may become aware in a new and helpful way of relations of shape and pattern that are quite independent of subject matter. Looking at a picture in this way, or studying your subject in a mirror, can have something of the same result.

Normal everyday vision, unless it is sometimes given a jolt, can all too easily become routine; we slip into a state where we do not really see at all. One of the greatest qualities of a painter like Bonnard, and one of the most precious gifts any painter can have, is that he has no routine of looking, apprehending everything freshly in all its strangeness and uniqueness. Look at the painting reproduced in Fig. 52. Every shape is painted as if it had been seen and delighted in for the first time. Yet the subject is commonplace enough, one which Bonnard must have seen almost every day of his life. This freshness, of course, is what Matisse meant by saying that he wanted to paint as a child of five saw.

Take a subject that is very well known to you in its normal aspect—a head, for example—and try to draw it upside-down (Fig. 53). If you can get hold of a plaster cast, the kind students used to draw from *ad nauseam* in art schools, it will make a very good subject. The average Greco-Roman cast falls into the category of objects that are very hard to see freshly—particularly for anyone who studied drawing before, say, 1950. But turn it upside-down, and you will be presented with an entirely new set of forms which

Figure 52. *Pierre Bonnard:* Bowl of Fruit. *Philadelphia Museum of Art. Here is a perfectly commonplace subject, seen in a way that is not at all ordinary. Bonnard has not let any preconceived ideas as to what fruit looks like get in the way of his fresh observation of such odd shapes as the shadow cast on the tablecloth, for example, and the light shapes of the tops of the pieces of fruit in the middle of the bowl. Observation of this kind is as creative an act as invention.*

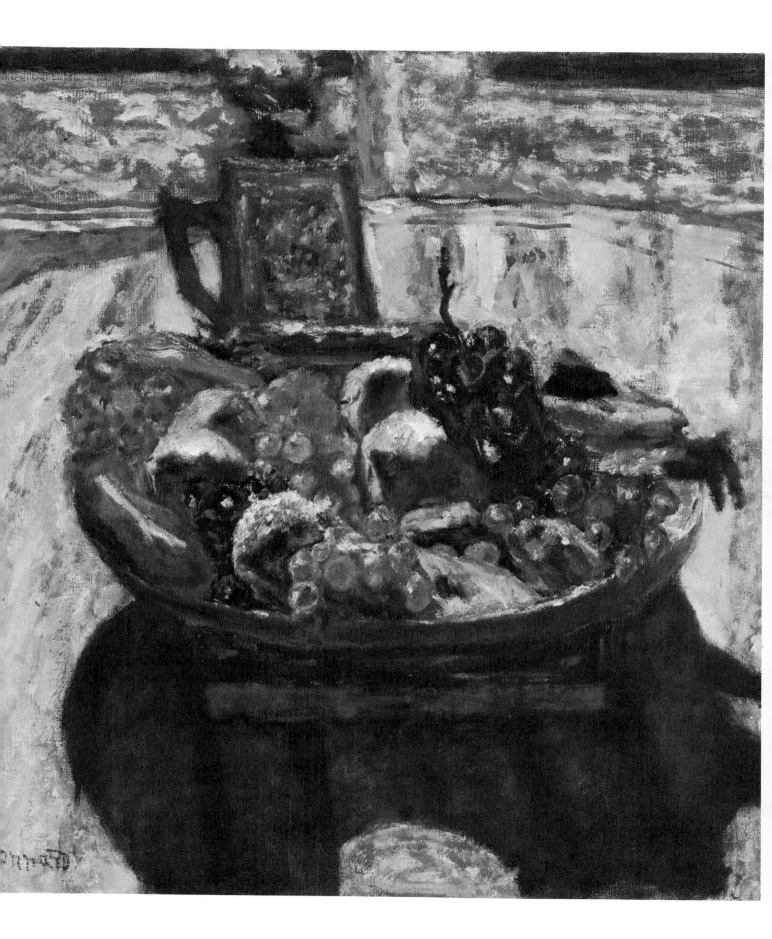

will have to be drawn as if you'd never seen them before. Your efforts to get these strange shapes right are likely to make your drawing, when right side up, more meaningful than a drawing done under the assumption that you know what it's all about.

You can try this with a living model as well. Have your model lie down and seat yourself just behind the head so that you can look down on it upside-down (Fig. 54, left). Or, for a more complex exercise, get hold of a large mirror and lay it flat on the floor. Have your model stand on it (make sure the mirror is really flat on the floor and will bear the weight). Now draw only the reflection. You'll have to get very close to draw the reflection, and the result will be a strangely steep and violent perspective (Fig. 54, right). Perhaps this is how Baroque artists produced the floating figures in ceiling paintings which show you the soles of their feet.

Pictures with strong abstract qualities or powerful rhythmic patterns can at times be worked on turned upside-down on the easel. Movements and connections which had gone unnoticed in the ordinary course of working can often be perceived. Even a portrait, turned the other way up, can sometimes reveal something unexpected, such as an exaggerated angle between the eyes and the mouth.

Forgers have long known that visual habits and formulas interfere with clear seeing. When they copy something particularly complex or subtle, they often turn the work upside-down.

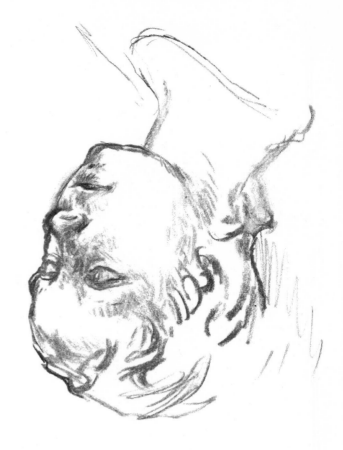

Figure 53. *In this drawing of a cast of a head, the subject was placed upside-down. An unexpected outlook, such as this, encourages you to observe all forms afresh, as if they had never been drawn before.*

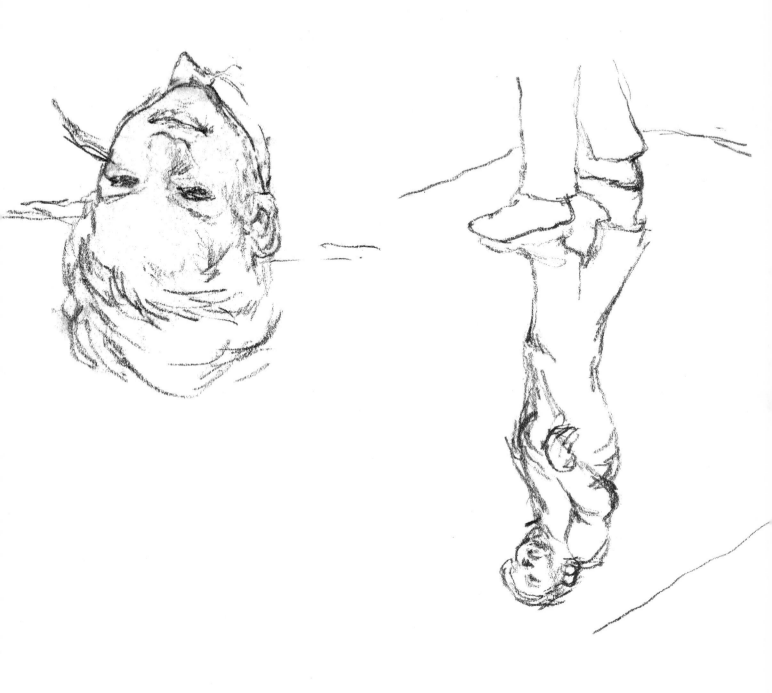

Figure 54. *A living model can be looked at in the same way as the cast in Fig. 53, although it may not be quite so easy to turn a person upside-down! In the drawing to the left this wasn't too much of a problem, however, as the model was lying down and could easily be looked at from above. In the drawing to the right, the model was standing on a mirror which was placed flat on the ground.*

12

SILHOUETTES AND SHAPES

A figurative painter has to be ready, at all times, to be surprised by the unexpectedness of his surroundings. This means that the eyes have to be, so to speak, opened wide enough to recognize the unexpected when it occurs (which is not as easy as it sounds). Welcoming the unexpected also means that we shouldn't be too worried about explaining everything.

The odd shapes that objects make when silhouetted against one another have always been an important part of the painter's language. When they are used as powerfully as in Uccello's *Battle of San Romano* (Fig. 55), they create a tremendous variety of shapes. This variety is one of the main reasons why, in my opinion, figurative painting is still more interesting to look at than all but the finest abstract art. It is extremely difficult to invent shapes as energetic and satisfying as those in Uccello's painting made by the armor, the banners, or the ground between the horses' legs.

The reproduction in Fig. 56, an early work by Pierre Bonnard, is of a very different sort of painting. In a summary way, with intentionally slight handling, Bonnard has done exactly the same thing as Uccello: he has selected from his observation of the world around him certain shapes that seem interesting and significant and brought out their characteristic oddities.

Bonnard's picture, in fact, concentrates on a small number of irregular shapes that come together—the woman's cape, her umbrella, and the dark shapes on the other side of the road. By running some of these areas together, while leaving other parts of the picture quite unresolved (the large lower division is little more than scraped-down thin paint allowing the wooden panel to show through), he makes an almost abstract statement. At the same time, the picture retains the quality of witty observation which probably attracted him to this familiar scene in the first place.

Extreme sensitivity to the character of the silhouetted shape is surely one of the constants which run through all pictorial art—whatever the period or country; and another constant factor is the "springy" and lively line which we discussed earlier.

A silhouette, in this sense, does not necessarily mean a complete and unbroken form. It can be, as is often seen in the works of Rembrandt or Caravaggio, merely a part or a fragment—a hand, for example, that suddenly gestures against the dark.

My final example, however, deals with exquisitely complete and separate silhouettes which are part of a Chinese scroll that goes back twelve centuries (Fig. 57). I don't think that refinement in the drawing and placing of flat shapes could go much further than this.

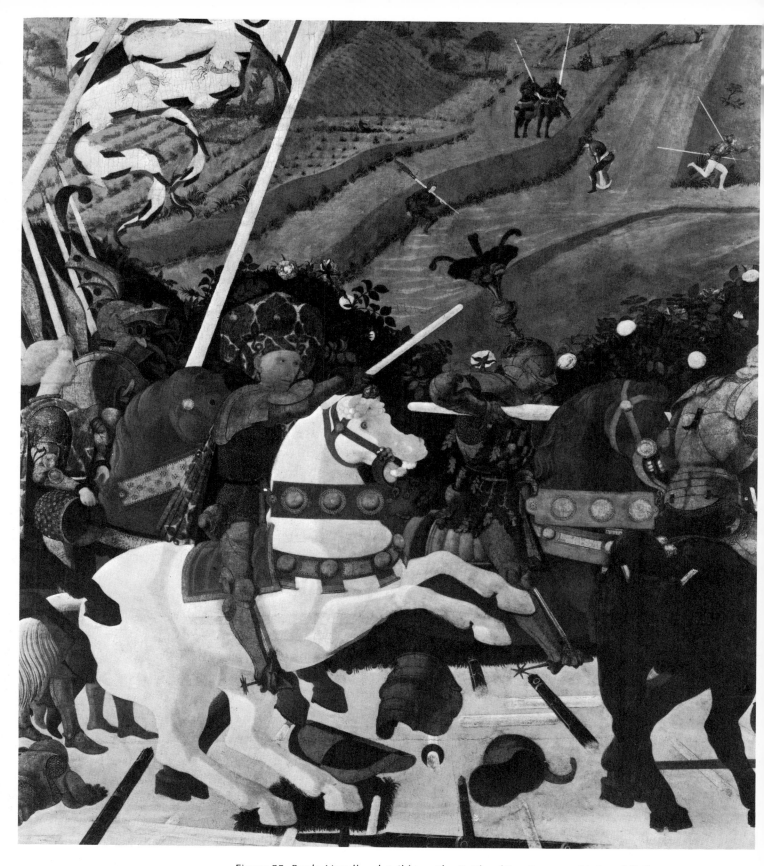

Figure 55. *Paolo Uccello: detail from* The Battle of San Romano. National Gallery, London. *Look at the lively and satisfying shapes made by the armor and the shapes of the negative spaces between the horses' legs. You could take any one of these shapes out and isolate it; it would still have an energetic quality.*

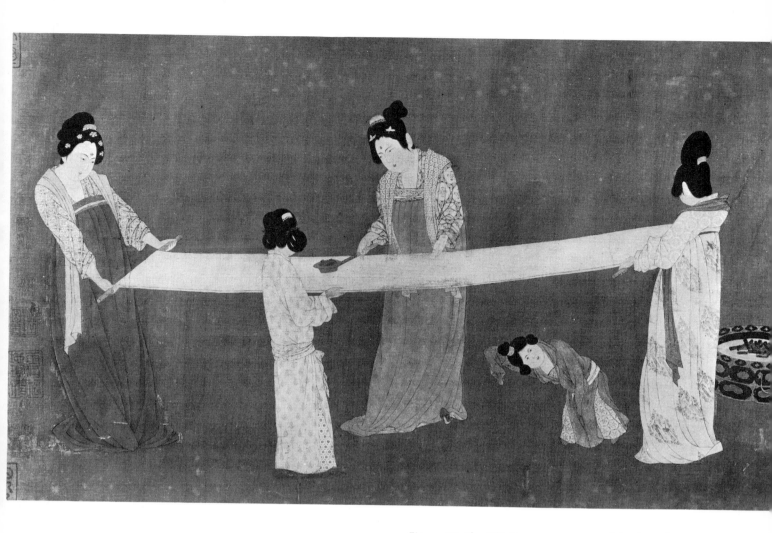

Figure 57. The Silk Beaters, *copy possibly after Chang Hsuan (active c. A.D. 713-742). Museum of Fine Arts, Boston. Here, silhouettes are kept quite distinct and separate and treated with extraordinary refinement.*

Figure 56. *Pierre Bonnard:* Study of a Street Seen Through a Window. *Photo courtesy Messrs. Arthur Tooth. However different the final results are, there is no essential difference between what Bonnard does here and what Uccello does in the preceding example: they are both observing the world around them and selecting shapes they like.*

13
A STILL LIFE PAINTING

The small study of a still life (Color Plate 2) will serve to demonstrate some of the ideas we have been discussing. There is no better subject than a still life for working out ideas about painting. It is the one subject that is completely under one's control; provided that the materials aren't perishable, it can be continued day after day under exactly similar conditions, and the arrangement and choice of subject are entirely up to you.

However, this doesn't mean that a still life should be regarded merely as a studio exercise. It's essential, I think, to choose objects that really interest you, to exclude anything unnecessary, and to forget all about the stereotyped arrangements of bottles and cloths which used to haunt art students.

This still life came about because I noticed some tangerine peelings about to be thrown away. The other components (all found nearby in the kitchen) seemed to come together naturally. A certain amount of conscious arrangement was necessary, but I kept the grouping as casual as possible. Sometimes things almost seem to arrange themselves; when this happens, it's a matter of choosing scale and viewpoint.

I must stress that the stages in painting the following picture are not included to demonstrate "method" of working, but merely to show how some of the points already discussed can be applied to an actual painting. Everybody must develop his own way of working; any method of painting is right if it works for the person who uses it.

This particular picture, it is worth pointing out, was carried out in a much more deliberate and conscious way than I would normally use, in order to make the demonstration clearer.

The first photograph (Fig. 58) shows the state of the

picture after about an hour of work. As you can see, the first consideration is the placing. Everything we've already mentioned—distances, angles, spaces, and so on—is continually cropping up. Adjustments of shape and distance have to be made all the time, not only at this stage, but right up to the last touch put on the picture.

Notice how the shadows cast by the objects (artificial light was used, by the way) are considered as carefully as the objects themselves. The areas in the background are also related as carefully as the objects on the table, as are the shapes between one thing and another. But the composition is still very tentative and changes—even quite drastic ones—can be made at every stage.

Some first, exploratory patches of color have been put on in various places; these will later be extended, joined, and overlapped by other colors. At this stage, I have purposely exaggerated the connecting marks drawn with the brush to judge distances between two or more points, so that you can see the kind of measurements being made at this stage.

The second sitting was a short one, which I mainly devoted to painting the tangerine skins before they dried up (Fig. 59). Nothing can really be painted in isolation, though. I had to keep the surrounding areas going at the same time, for the orange and white tangerine skins could be judged only in relation to the color of the cardboard behind them. In this instance, as in all cases of painting perishable materials, one part of the picture had to be taken to completion long before the rest; this painting, however, was far enough advanced so that this discrepancy didn't matter.

At the third sitting, a much longer one, I worked on most parts of the picture. In addition to the inevitable small drawing adjustments, I carried the exact tonal and color relationships much further at this stage. I continually made careful comparisons of similar or nearly similar tones and colors. For example, the tone of the dark jar is similar to the tone of the dark part of the background, but its color is much warmer; and the shadows cast by the objects are subtly different both in tone and color. Even the cardboard on which the objects rest can be seen to vary between a warm, brownish color and a cooler gray, according to the way the light falls.

Regarding the formal relationships that we've been working, I might mention that I looked at and adjusted every gap between the objects as if it had been an abstract shape in itself, and I made continual checks by plumbing and by referring to horizontal levels.

The final stage of the picture is shown in Color Plate 2. As you can see, no very drastic changes have taken place. Some final adjustments of relative sharpness and accent—though they probably don't show much here—were quite important in pulling the study together.

I'm sure that doing simple and direct still lifes on a fairly small scale like this one can be very useful in developing your sensitivity to basic painting skills. This is especially true if you can be fairly ruthless and not allow yourself any evasions or slick solutions, but simply try to understand and put down what is there.

However, still life painting should never be regarded as merely an exercise. To get the most out of it you must enjoy it; choose objects whose shapes and colors really interest you. Don't add anything to your arrangement merely because it looks like the sort of thing you are used to seeing in still lifes.

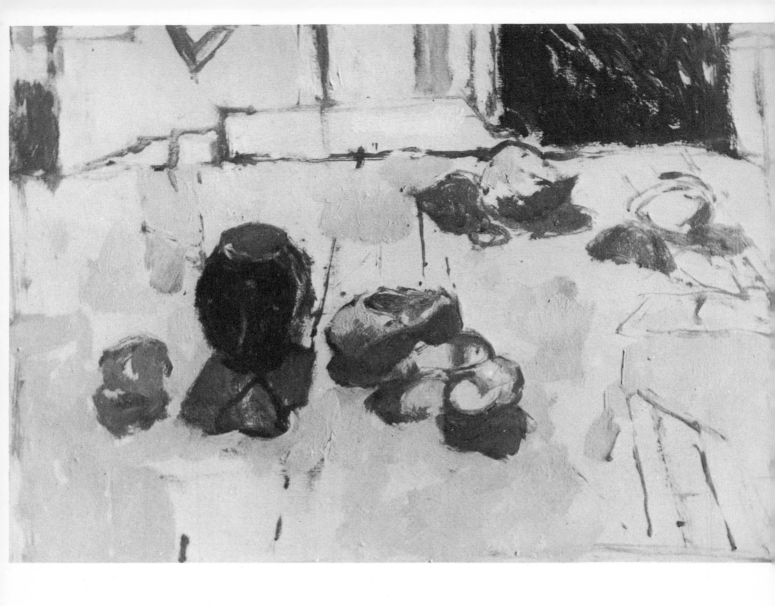

Figure 58. *This photograph shows an early stage in the painting of a small still life. The shapes have been placed within a rectangle and a few patches of color have been related to each other, but everything will have to be adjusted and readjusted many times. Notice that the shadows cast by the objects are considered to be just as important as the objects themselves, even at this preliminary stage.*

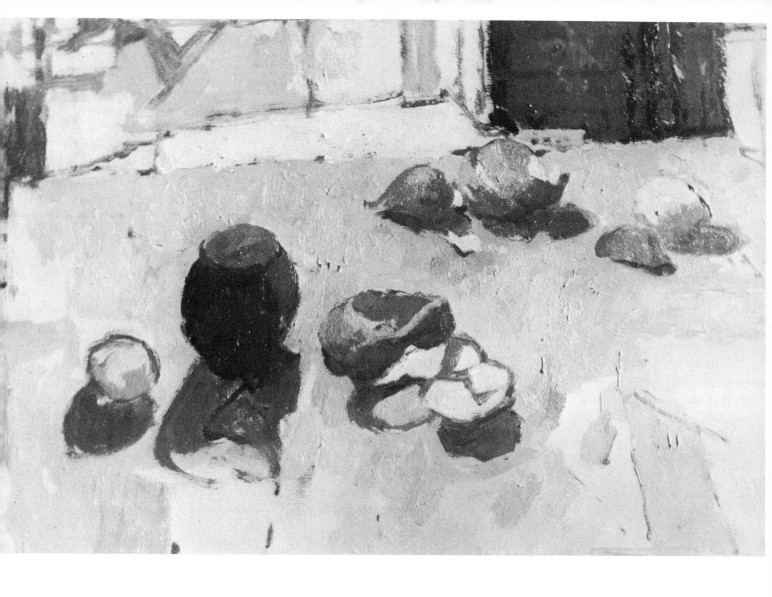

Figure 59. *Here is the painting begun in Fig. 58 after a second sitting. One part of the setup, the tangerine skins, had to be attended to and taken almost to completion before the rest of the painting; they were beginning to dry up. However, color relationships in the neighborhood of these areas were built up a good deal, as nothing can be treated in isolation.*

I must confess a certain diffidence regarding my ability to write about color, which is a notoriously difficult subject to communicate in words. I have seen too many students dutifully complete innumerable color exercises only to produce confused and insensitive color relationships when they paint their own pictures. On the other hand, I am glad to say, I have also encountered students who have an innate and instinctive color sensibility. These contradictory experiences have made me doubt the possibility of teaching anything about color. The sections that follow, therefore, are merely exploratory, an attempt to introduce possibilities and to discuss color on a practical basis.

Of course, from Goethe onwards, many attempts have been made to evolve theoretical systems of color. These range from purely scientific systems dealing with frequencies of light waves, to esoteric theories that relate color to musical keys and relationships. Neither of these extremes is likely to help painters, who want to know the physical behavior of color in empirical terms. Theoretical discussions of wave lengths, even of complementaries and primaries, don't solve the practical problems of applying patches of paint on a canvas.

The study of color has become an important part of art school training in the last few years. Students are now given quite complex color exercises right from the beginning. In the old days, when life drawing and tonal painting from the model formed the major part of a student's training, color was often treated as a purely personal element, one which would evolve after other, more tangible studies had begun to bear fruit. A "color sense" developed out of monochromatic beginnings; if it was slow to arrive or not forthcoming, it didn't matter too much; there were many other skills to concentrate on.

But nowadays, when the abstract qualities of painting are emphasized, and when so many abstract painters are involved in teaching, students have become far more aware of color as an essential part of the structure of a picture. One result of this is that color studies have now become the contemporary academic discipline, usurping traditional disciplines like anatomy and perspective. An unfortunate outcome of this new focus is that people with no innate color sense (who in the old days would be working more or less in monochrome) now feel it neces-

sary to use intense color. Consequently, there is probably more nasty color to be seen now than ever before in the history of art. An example of what I mean is the sham-modern landscape in which an essentially monochrome conception is arbitrarily transposed into fierce reds and oranges.

How much a theoretical study of color can help a painter depends, of course, on the sort of work that he is involved in, and on his personal approach and preferences. A painter with a strongly figurative bent who likes to work with the subject in front of him will gradually develop a way of handling color that grows from observing and analyzing his subject; he really needs no other knowledge. But such painters are in a minority nowadays (and probably have always been so). Most painters, even when figurative art is their main preoccupation, sometimes need to invent color relationships or to key a picture to a particular color mood. A painter who is largely concerned with imaginative or non-figurative idioms will continually use color in an inventive way.

Almost any painter, however, can derive some value from practical color studies—even if it's only a heightened awareness of the characteristics of the material that he's working with.

To avoid the danger of what I would describe as the academic-abstract approach, I suggested that exercises using color in a non-descriptive way should always be carried out in conjunction with the observation and study of actual color seen in nature. Each activity helps the other; neither is complete without its counterpart.

14
THE COLOR WHEEL

A very basic exercise is to construct a color wheel, as is shown in Color Plate 3. This project is not merely the mechanical task of taking pure colors straight from the tube and arranging them in a circle. You will find, if you try this experiment, that a good deal of adjustment is necessary; some colors will have to be lightened or otherwise altered to achieve a steady, even progression. The problem of color adjustment, to my mind, is the real value of the project: not learning facts about colors, but developing skill in making exact mixtures and exact relationships.

Many different varieties of color wheels have existed since Isaac Newton first had the idea of "bending" a spectrum of seven colors to form a continuous series. Of these, the color wheel illustrated here is the most useful for our present field of inquiry. Known as a tri-chromatic wheel or circle, it is based on the primaries—red, yellow, and blue.

To carry out the experiment, try to "balance" each color in exact relation to the others. First, attempt to establish a red, a yellow, and a blue that fall, as closely as possible, in the middle of their respective color fields: the red must be a pure red which leans neither towards orange nor violet; the yellow should show no trace of either green or orange; and the blue must be innocent of both purple and green. Needless to say, all these colors must also be pure in the sense that they are not grayed or degraded—even though they may have to be mixed on the palette with other colors and with various amounts of white added to adjust the intensity and tone of each color according to its place in the circle.

Once the primary colors are established, the three secondary colors are added by mixing each from a mixture of two primaries: red and blue for purple; yellow and blue for green; and yellow and red for orange. These colors, too, must "sit" precisely in the middle of their own chromatic field and not lean towards either of their component primaries. Again, a certain amount of adjustment will be necessary.

Finally, mix the tertiary colors from equal amounts of a primary and a secondary (for instance, blue and green to make a blue-green). When the wheel is complete, you may well find it necessary to repaint one or more colors and to adjust their tone or intensity so that the transition from one color to another is smooth, without "jumps" or breaks.

By the way, in carrying out any color exercise, it is quite important to aim for a flat, solid quality and to establish precise edges between the colors. Otherwise, they will not react positively to each other.

15

THE NOMENCLATURE OF COLOR

An absolutely natural, instinctive sense of color is a rare gift, one that young children are much more likely to possess than adults. A painter who is blessed with a natural color sense doesn't need any verbal concepts to understand color. On the principle of "naming a thing in order to understand it," the rest of us may as well look at the words we use to describe colors and thus try to define them more clearly.

Words like "tint," "tone," "shade," and "hue" are often used loosely and confusingly. A more precise classification of color differences will help us to analyze what we are looking at. Each patch of color, whether we perceive it in a picture or in nature, or whether it is pure or mixed, brilliant or dull, has certain characteristics which can be classified into three categories: warmth or coolness; tone, light or dark; intensity or saturation.

My own painting, *The Shower* (Color Plate 5), illustrates these categories. First, warmth or coolness. It is fairly obvious that the figure in this picture is generally warm in color, while the shadows on the wall and bath are bluish and cool. Any red or orange is warmer than any blue. However, we can extend the analysis further. Within the blue range, there are warm blues and cold ones. The warm ones may be greenish, or they may incline towards violet. The area at the top right of this painting, for example, is warmer blue (more violet) than the patch at the bottom of the picture. Moreover, one violet-blue can, of course, be warmer than another.

Color temperature, then, is a relative matter. In the broad sense, the spectrum can be divided into warm and cool colors; but in comparing any two colors or variations of one color, we can say that one is warmer than the other. Thus, the blank wall at the left of the picture shifts from a creamy to a pearly color. There are certain areas in the painting which, if taken separately, would be more or less neutral from the point of view of the spectrum, but which appear warm or cool according to the color they're next to.

You can try the well-known experiment, if you like, of placing a square of neutral gray on a larger square of intense pure color (Fig. 60). It will help if the two are similar in tone. The temperature of the gray will be influenced by the color that surrounds it. Tone (or value) is the darkness or lightness of a color in relationship to black and white. Colors inherently have their own tones or values. If you set out your palette with a full color range and then peer at it through half-closed eyes, you'll see that blues, greens, and browns are collectively almost indistinguishable be-

Figure 61. *A small area of solid black balances a much larger area of gray.*

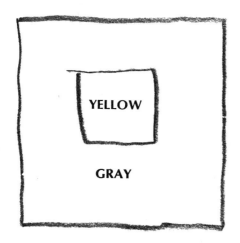

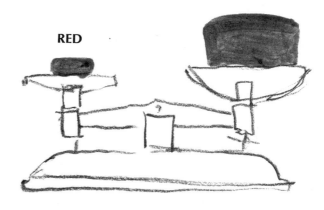

Figure 62. *An intense red can be thought of as being equivalent to a larger, but less intense, area of grayish blue.*

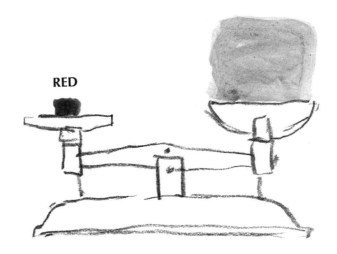

Figure 60. *The intense color on which the neutral gray square is placed should make the gray look different by contrast. Try it for yourself, experimenting with the effects of different sizes and amounts of pure color.*

Figure 63. *A smaller area of red than we saw in Fig. 62 balances in the same ratio a paler gray-blue. Try some experiments with actual colors and see what your feelings are about their relative "weights."*

cause their tones are all naturally dark. Yellows, on the other hand, are inherently light.

The "natural" tonality of a hue can, of course, be modified or even altered by mixing, as you discovered when you made your color wheel. You can easily make a cadmium yellow and an ultramarine blue the same tone by mixing white with the blue, and darker colors with the yellow; you can go even further and make the blue much lighter than the yellow. But in doing this you will drastically change the character of the color as well, altering its intensity and its natural warmth or coolness.

It is sometimes quite difficult to judge the tonal relationship between two very opposed colors. Notice, for example, the bright red soap and the blue flannel in the extreme foreground of *The Shower*. Are they tonally similar? If you're in doubt, squint and look again, quickly switching your unfocused gaze from one color to the other. This should enable you to see the two areas more as tones, by diminishing the color change; but it is only a very rough indication, as the tones will be simplified as well as the colors.

A fully saturated color is one that is at its peak intensity when, so to speak, it is nothing but itself: the reddest red, the most crimson of crimsons. Any mixing will reduce this intensity. The colors that you have squeezed from their tubes onto your palette are all at their full intensity, in that they haven't been mixed or diluted. Naturally, while the intensity of each color can vary, some colors are clearly more intense than others. Prussian blue and Indian red are inherently more intense than terre verte and yellow ochre; they are very powerful colors, as anyone knows who has found his palette, and perhaps picture, too, swamped by them. Grays, on the other hand, always have a low degree of saturation.

It is important to think of color as an active force in a picture, and not merely as a descriptive or decorative addition. Color can act like a weight that steadies, or like a force that pushes. Here is one way of looking at color, which uses the concept of weight or force.

We can think of a small area of black as if it made an equivalent impact as, or balanced, a much larger area of gray. We can put this idea into visual terms by drawing the two areas as if they were on a pair of scales (Fig. 61). In just the same way, imagine an intense red balanced against a larger amount of, say, a grayish blue of the same tone. An even smaller mass of the red would be needed to balance a light gray-blue (Figs. 62, 63).

Now make some small diagrams of this kind yourself, using actual colors, and experiment to discover the amount of each color that is needed to make an equivalent force, to "balance" the scales.

Needless to say, the color in an actual painting hardly needs to be balanced so precisely; nevertheless, small adjustments of intensity and quantity do have to be considered all over the picture if color is going to be used constructively. Small amounts of solid, intense color may often be placed in a painting almost like heavy weights, creating an equilibrium against larger areas of less intense hues. In *The Shower* (Color Plate 5), for instance, the red soap in the left bottom corner and the orange shapes of the right-hand edge form concentrated and important "weights" of color. You'll find, I hope, that the simple, abstract experiment outlined above may help you to think of relative color intensities in this way.

16
MOVEMENT OF COLOR

The terms "advancing" and "receding" continually crop up in any consideration of the part that color plays in painting. Everyone has been told at some time that warm reds and yellows "come forward" and that blues "go back." The idea that warm colors advance and cool colors recede has sunk so thoroughly into some students' minds that they think it must apply to all circumstances. Look at your completed color wheel and try to decide if it is happening here.

Whether colors are recessive or prominent depends very much on factors other than just their warmth or coolness. Color can influence the movement or stillness of a form; however, it's not the only active ingredient in a picture. For example, the texture of the color will make a difference: a speckly, active surface, obviously, will tend to come forward, as will a passage painted in a thick impasto. The tone of a passage in relation to its neighbors is also very important. But the most critical factor of all, one which has nothing to do with color, is the character of the shape itself.

Look at Color Plate 4. On the left are two pure, flat colors, orange and blue. By all the rules, the hot color—orange—should push forward against the cool one. But as soon as these shapes are adjusted so that one square seems to overlap the other, as in the second example, the reverse happens. Our perception insists that the blue is in front. This simple exercise demonstrates that shape actually exerts a much greater influence than color in creating movement within a picture plane.

The idea of advancing and receding colors is a very old one. The old landscape painters, such as the Dutch artists of the seventeenth century and the French painter Claude Gelée (Claude Lorraine), all followed the recipe of using browns in the foreground and placing cool blues to keep the distance firmly in its place. This illusion was helped, of course, by the natural scale and overlapping of receding shapes. John Ruskin, the British art critic and author, scorned the unthinking and academic application of this idea. He pointed out that nothing could give a greater feeling of space and recession than a sunset sky full of golden and red clouds. According to academic rules, these warm colors should come forward. Yet a shadowy, cold blue cloud moving across such a sky is seen at once to be lower and closer. Ruskin then proceeded to ask whether anyone, in looking at two pots of paint—one yellow and the other blue—adjacent on a shelf, could possibly claim that the blue one receded!

It is worthwhile making some simple experiments

Figure 64. *This divided rectangle can be as easily read as light on dark as it can be read as dark on light. Try painting the areas different colors and see if you are aware of any recession or movement.*

to investigate color movement. To do this we must deal with "neutral" shapes which in themselves imply no recession. Divide a rectangle as in Fig. 64, so that it can be read either as a dark shape on a light ground or *vice versa*. Paint each of the two areas a different color and in contrasting tones. For instance, use a dark red against a pale blue, or a dark blue against a pale yellow. On a fresh sheet of paper, set up your rectangle as before, but make the tones exactly similar so that there is no light-dark contrast, only a change of hue. Try many combinations of color, intensity, and tone to produce different activities in the figure-ground relationship.

Finally, remember that the question of forward and backward colors depends entirely on what sort of picture you're painting. Sometimes it's necessary to adjust the color intensity so that no movement takes place and everything lies flat on the picture plane. The idea of using color to create space has by now become almost an academic commonplace, but there's no virtue in creating space and movement for their own sake, whether through color or perspective.

The relief by Ben Nicholson (Color Plate 6) very skillfully produces a curious ambiguity between movement and quite static elements. The only color in this picture which approaches purity is the blue of the small central rectangle. It is easy to say that this blue area recedes because of its color. Nicholson has chosen the most recessive color possible (its associations with sky and infinity psychologically help us to place the blue in the distance). Moreover, the rectangular shape can be "read" as a window-like space. But when we look at the surrounding shapes, we aren't so sure. Do these three rectangles overlap or not? Our reading of the color movement is affected by the way we decipher these shapes.

17

THE USE OF GRAYS AND NEUTRAL COLORS

Neutrals and grays are important elements in the intelligent use of color and should never be considered insignificant or negative. They need just as much thoughtful attention as pure colors do.

Beginners often feel that grays are dull and treat these neutral parts of the picture accordingly with unconsidered mixtures applied without enjoyment. In portrait painting, for instance, while the color of the flesh and the clothes may be put down with a certain enjoyment and care, its satisfactory relationship is often destroyed by muddy and uncertain mixtures placed in neutral areas such as the background and the shadows in the flesh.

Watch a good painter at work and you'll certainly find that he mixes and places his neutral colors every bit as carefully as the strong ones; he may spend even longer mixing up a gray on his palette than he does a bright color. The inexperienced painter, on the other hand, will probably scrub an indeterminate color mixture onto the canvas and then try to remedy the situation by rubbing still other colors into the same area.

Occasionally you may come across the belief that black should not be used in mixtures. Some amateur painters have had this principle so drummed into them that even if they are painting a solid black or an absolutely neutral gray area, they will mix together all the dark colors on the palette rather than use black. Yet every great painter from Velasquez to Matisse placed black on his palette. The only period when this color was banished was during the more doctrinaire stage of Impressionism.

One can certainly say that the great colorist reveals himself just as much by the way he uses grays, blacks, and neutrals as by the way he uses stronger colors. Think of how Rubens uses pearly grays in flesh; or both Manet's and Velasquez's full flat areas of silvery tone against which pinks, whites, and blacks sing out. And in more recent times, Toulouse-Lautrec, Bonnard, Picasso, and Matisse have all used neutrals positively—as foils against which their positive colors can be seen to full advantage.

The picture by Edouard Vuillard (Color Plate 7) is a very good example of the use of tender and subtle grays. The main areas are made up of a grayish blue, a warm dark gray, and a violet gray. I would be surprised if black didn't come into all these mixtures. Notice, by the way, how the ground color (in this case, gray paper) is allowed to show through everywhere and, moreover, is used for the actual color of the woman at the right. In spite of the general gray-

ness of these mixtures, the whole effect is rich and full, largely due to Vuillard's masterful use of tone.

The danger of black lies entirely in using it incorrectly—to darken or subdue a color already on the canvas. This practice always leads to muddiness.

The following exercise with grays and mixtures of grays may be more helpful than my explanations. Take a piece of white board and divide it into a grid of squares, as in Fig. 65. The squares need only be about half an inch in size. Paint each of the central vertical series of squares with a different pure color, applied straight from the tube. You could start with yellow at the top and go down through the spectrum to blue at the bottom; or if you prefer, take only two or three colors at first. Taking each pure color in turn, make a series of mixtures of it and black, placing the mixtures so that they form a gradated horizontal series to the right of the square of pure color. The first square will

be a mixture with very little black, and the last one on the right will be nearly pure black. Try to make each square "in tune" with its neighbors: you are trying to make a gradated series as regular as the notes on a piano keyboard.

On the left side of the pure color, make another horizontal series, this time mixing each color with white and black; attempt to keep the mixture exactly the same tone as that of the original color. The last square on this side will thus be almost neutral gray.

If you carefully prepared in advance these mixtures on the palette and then placed them flatly and precisely in position, you should discover that instead of making muddy colors, you are creating a whole range of beautiful and useful grays.

You will find it instructive to extend this experiment by taking any one of these mixtures and trying to duplicate it exactly without using any black.

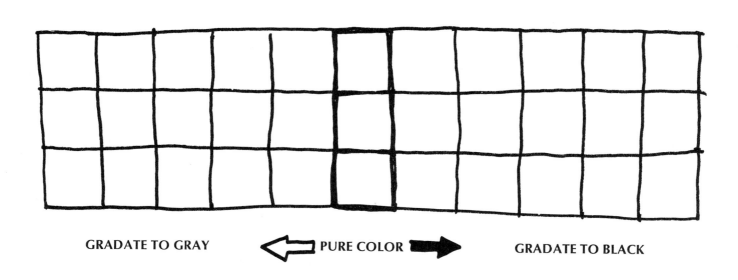

GRADATE TO GRAY ⇐ **PURE COLOR** ⇒ **GRADATE TO BLACK**

Figure 65. The pure colors in the center of this chart are mixed, in increasing amounts, with black to the right and with black and white to the left.

18

EXPLORING COLOR THROUGH A LIMITED PALETTE

Like too many changes of key in a piece of music, too many colors in a picture will diminish, rather than increase, the total color effect. We can, in fact, think of a picture as being composed in a certain "key" of color. Many pictures that have an immediately interesting color scheme can be described, for example, as a "blue picture" or a "golden picture." In other words, color relationships are often related to one dominant key, with perhaps an opposing element present to prevent monotony.

Thus, great colorists like Turner or Monet often painted an entire picture in a blue tonality opposed by a strong warm or golden area, or a golden picture opposed by a blue area. This very simple kind of "chord" is capable of infinite and subtle variations.

Many pictures fail to be interesting in terms of color because they lack some large, simple scheme; instead, little areas of opposed colors are placed over the entire canvas and end up by canceling each other out. Such pictures may contain numerous colors—but very little true color.

A fruitful exercise is to paint a picture in a single color and a number of variations on it, in conjunction, perhaps, with small areas of contrasting hues. Such a painting can best be done by working away from the subject rather than on the spot, so that you feel quite free to invent and improvise.

As you have begun to discover from the previous exercise in color mixing, each hue can be developed into an enormous range of possible mixtures. Here is another "scale" to try, this one based on pure colors.

Draw an odd numbered row of squares. Select two colors that are sufficiently different from each other, say a red and a blue. (Remember that any two colors on your palette can be mixed to produce useful results, so don't necessarily choose the most obvious hues. For instance, crimson and viridian will produce a quite unexpected range.) Place a pure and unmixed square of color at each end of the scale (for example, red at one end, blue at the other). Now, with some care, try to mix exactly the same amount of the two colors, and place this color in the center square. Fill the other squares with regularly adjusted mixtures of the red and the blue to make a gradated scale that goes from pure red and moves through mixtures that gradually contain increasing amounts of blue, to the half-way violet, and so on toward pure blue at the other end: no sudden jumps! Then, if you wish, pick out three or four of these mixtures and use them to paint a small picture, with perhaps one other contrasting color and an area of contrasting tone.

In the use of a limited color range—in fact, in any use of color—the opposition of warm and cool is of very great importance. Adjusting these "temperatures" so that they relate to neutral gray, on the one hand, and pure color, on the other, is at the heart of all good color. The painting by Gwen John (Color Plate 8), a very beautiful example of the use of a limited color range, is based on a cool-warm chord of bluish and pinkish violet, with muted buffs and brownish grays in the wall behind the figure. No stronger colors are used. In other hands, such low-toned color might result in a lack of vigor, but Gwen John's mastery of tone and drawing give this little picture an air of tender grandeur.

Another picture which uses a very limited palette is the small study by Walter Richard Sickert (Color Plate 9). This sketch, *St. Jacques, Dieppe,* was almost certainly painted on the spot, perhaps with the wooden panel held in the lid of a paint box. The warm color of the wood, which is unprimed, though probably sized (it may have been originally a cigar-box lid), is allowed to show through the thin paint in almost every part of the picture, becoming, in fact, one of the colors in the range.

The other colors in the Sickert painting are simply a black and a creamy white, two grays, and the tender blue of the sky. This last, by the way, is the only large area to be gradated, and this procedure has been carried out most carefully and subtly. By contrast, the other areas have been scrubbed in rapidly, while the drawing and the accents have been "written in" either directly on the panel or over the thin areas of color. The road is painted so quickly and thinly that a pencil line drawn horizontally across the panel is not covered. Obviously, in painting this study, everything in Sickert's method is aimed toward a rapid and direct execution, and the small range of colors contributes greatly to the total effect.

RED					VIOLET					BLUE

10 RED / 0 BLUE	9/1	8/2	7/3	6/4	5 RED / 5 BLUE	4/6	3/7	2/8	1/9	0 RED / 10 BLUE

Figure 66. *The approximate proportions of each color mixture (shown by the fraction under each square) need not be attempted with scientific accuracy. Gradations from one square to another should, however, be carefully gauged by the eye.*

19

USING AN UNLIMITED PALETTE

There is no particular virtue, as is sometimes supposed, in limiting your palette to a bare minimum of colors. Certainly, it's valuable to learn how much variety can be obtained from a small number of colors, but it seems to me equally important to experiment with all the colors you can get your hands on. You want to explore the possibilities of mixing any color, which can only be done with an extended palette.

The danger of getting accustomed to a limited palette is that you may begin to rely on the same mixtures. Especially when you paint from nature, it simply isn't possible, with four or five colors, to match all the subtle hues in, for example, a head. In such cases, equivalent colors must be used. To some extent, colors are always approximations, but the business of matching is a very important part of the learning process of handling color. Until you've tried to mix up a color to just that particular warm green or purple-gray, you haven't really looked at or analyzed those colors.

The two approaches to using color—limited and unlimited palette—can be carried on side by side. I've just counted the number of different tubes of paint on my table. It comes to twenty-three, including white and black. I may paint a whole picture using only six or seven of these, or I may find myself using four different reds and five blues during a day's painting.

If you're buying paints and your eye is caught by a color that you like the look of, get a small tube and try it. You may never buy it again, but only in this way can you enlarge your knowledge of color and arrive at a palette which suits your own purposes. Even then, you'll probably find that your range of colors is continually changing.

20
CLOSELY RELATED COLORS

Here is another experiment in creating exact relationships of colors. Take a piece of paper or board, and using an opaque paint—oil, acrylic, or gouache, because you'll be superimposing one color on top of another—cover half of your ground with a dark area of color and the other half with a lighter tone (Fig. 67, left). It doesn't matter much what the colors are as long as they are applied flatly and solidly. They can also be of different hues, perhaps a dark violet and a lighter blue.

When this ground is dry, begin to cover it with different colored vertical stripes, mixing your colors to the exact tone of the ground (Fig. 67, right). Leave some stripes of the original color showing between some of the superimposed mixtures. Try to make the color values distinct from one another, while preserving with great care the tone of each side. Don't paint the stripes mechanically. You'll end up with a series of dark and light stripes, all different in color, yet consistent in tone.

The purpose of this exercise is to find out something about color of which textile designers are very much aware, but which painters often ignore. This is the fact that colors closely related within a tonal key can be made to work together in subtle ways. For example, a red and a green that might be discordant or might "jump" were their tonal values different, will have quite another effect when their tones are similar. Some of the most harmonious color combinations occur within a limited key. A study of Impressionist pictures, Indian and Persian miniatures, and contemporary non-figurative painting will show the extreme subtlety, for instance, of a patch of intense violet glowing in the middle of a blue that has a very distinct hue but a tonal value identical to the violet. For still other examples, look at some good modern textiles.

Areas painted in close relationships can be contrasted with other areas in a picture which manifest differences of tone as well as of color. The monotony in many amateurs' pictures may be traced to an apparent, but unconscious, tendency to make every patch of color differ in tone from its adjacent area.

Develop this experiment further by altering the width of the stripes in accordance with the intensity of their color (Fig. 68). Thus, the hue of intense red, even when its tone has been reduced to relate to its neighbors, will still be much stronger than the hue of a brown or a gray. By making the red stripe very narrow and the brown stripe wider, we can "balance" one color against the other to make a closer relationship.

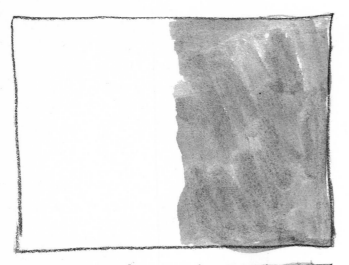

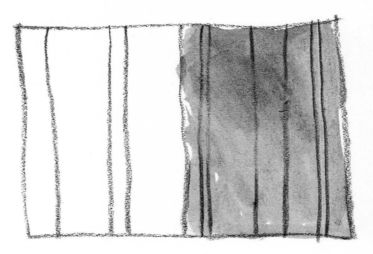

Figure 68. *Alter the width of the stripes according to their color intensity: a dull blue stripe might thus be wide, an intense orange stripe narrower.*

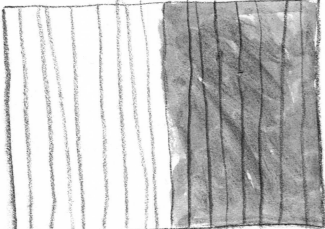

Figure 67. *Start with two areas of tone that make a plain division (above). On each side, paint stripes of color (below). These can differ widely in color value, but should match the lightness or the darkness of the ground tone as exactly as possible.*

21
TRANSPOSED TONE AND COLOR

In much the same way that a musician transposes a piece from one key to another, so can a painter transpose the tone and color of a picture—for example, into a dark or a light tonality or into a blue-gold or a blue-red color relationship. To some extent, we as painters necessarily do this even when we make a simple sketch from nature, because the range of tone and color in the subject is likely to be much wider than we can attain in terms of paint.

This is most obvious in the case of tone, whose range in nature from darkest dark to lightest highlight is enormous. Suppose we're painting an interior of someone reading a newspaper in the light of a lamp. The newspaper is practically pure white; however, if we paint it white, we have nothing left with which to "match" the even brighter lamp. Painting both newspaper and lamp with white pigment straight out of the tube will not solve the problem because it ignores all the color differences between the two objects.

The traditional way of dealing with this problem is to lower the general tone of the picture. The lamp and the paper are, respectively, still the lightest and the second lightest areas, but as we are no longer forced to pitch the light to its maximum, we can make the subtle differences between the two.

Rembrandt often handled his tones this way. Hold a white paper next to the apparently brilliant white drapery in one of his portraits, and you will probably find that its tone is actually comparatively low. However, the drapery looks comparatively strong and pure because of the scaled-down tones throughout the rest of the picture.

If we think of tonal scale in terms of a piano keyboard that runs from extreme light (the high notes) to black (the low notes), it's easy to see that we may select the particular dark-to-light "pitch" that we want to use—"a" or "b", for instance—resulting in a high-key picture or a low-key picture (Fig. 70).

The color, as well as the tone, of a picture can be transposed in just the same way. Color can be modified by working in a dominant color range (for instance, a blue picture or a golden one); lowered towards a neutral monochrome; or heightened, so that all the colors are intensified. However the colors are modified, the important point, as with tonal transposition, is that the process be consistent. Forcing one color and leaving the others as they were will produce jumpy and feeble results. Look at a Van Gogh or a Fauve painting to see how this intensifying process is sustained throughout the range of color used. *The Bathroom* (Color Plate 11) illustrates this point.

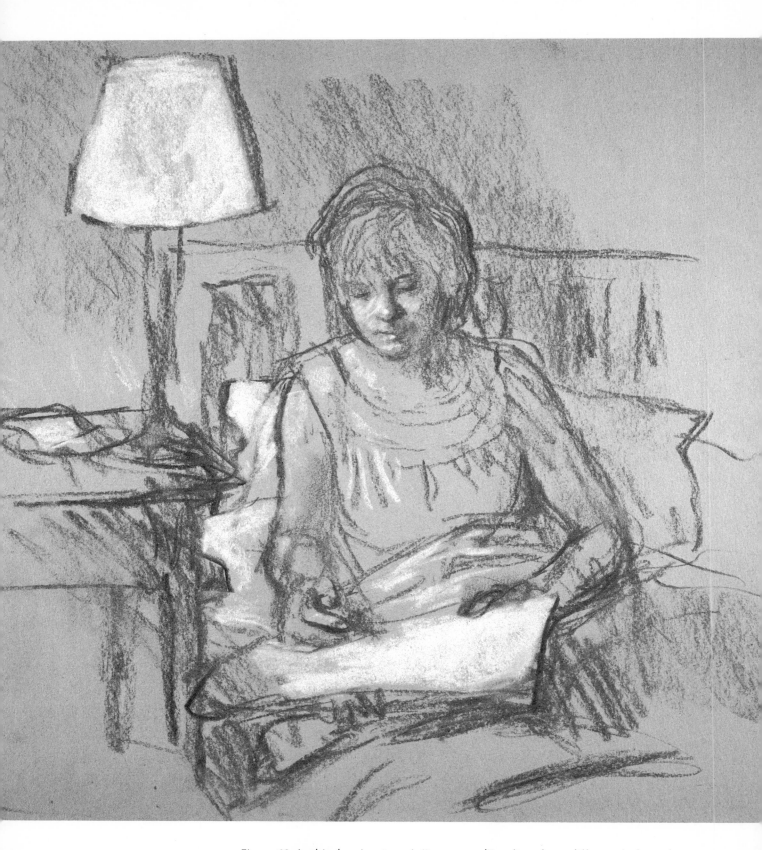

Figure 69. *In this drawing, tone is "transposed"—altered to a different scale—when the same tone is used to represent both the white newspaper and the much more intense brilliance of the lamp.*

Since Post-Impressionism and Fauvism, painters who previously would have worked within a limited palette have felt free to intensify color to its limit. The result has, I'm afraid, been an epidemic of insensitive and hideous color. The comparative safety of "sticking to appearances" at least kept bad colorists under control!

Intensified color is more likely to work if a definite color idea acts as a limitation. A number of fierce, unrelated colors will only nullify each other. The more powerful the colors, the more necessary it is to use them rationally, for color is not only an emotional matter. The most intense color is not necessarily the most telling. Colors transposed into a very limited range can be equally useful. This exercise is designed to widen your sensibility towards subtle variations of a single color.

Collect as many objects in a single color range as you can lay your hands on. For this purpose, if you select "red," this color can be taken to stretch from orange-red to violet-red and warm brown (see Color Plate 19).

Jumble all these red objects together on the floor. Now, as accurately as you can, paint these patches of color as you see them, in terms of their hue, intensity, and area. The purpose is not to paint a still life (though it might well develop into one), but simply to observe and note the color differences. The fact that your accidentally assembled patches will include larger and smaller areas is important. Notice how a very small amount of, say, a brilliant orange may "balance" a relatively large area of color that has a lower intensity.

Then, retaining these differences in intensities and tonal values, and using your red picture as a guide, paint another version of the same subject in which you transpose all the color into a complementary range. If you use the color wheel as a guide (Color Plate 3), you'll see that each value of red can be translated into its complementary value of green: a red-violet will become a yellow-green, a red-orange will become a blue-green, and so on. Try to retain the relative intensities of the colors when you transpose them, even though the act of transposition may tend to alter these intensities. For instance, if a yellow-green is more intense than its original red-violet, you may have to adjust the size of this color area as well as modify its color.

If your original color range lends itself to it, do another series of transpositions in which you simply intensify all the colors. Then try a fourth version in which you reduce all the values to grays of differing hues. As you work, keep an open mind about what's happening. That is, be prepared to change your mind and alter the painting if you decide you like the look of some effect that emerges. Personally, when I paint a subject which is important to me, I cannot "alter" colors arbitrarily because I have too much respect for the actual character of the object to depart from it beyond a certain point.

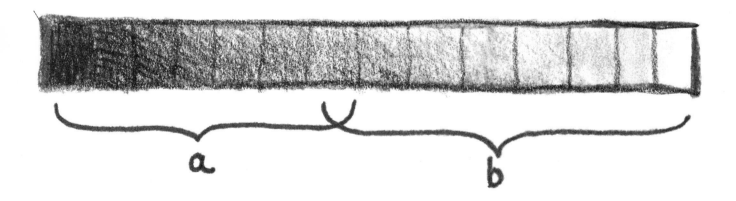

Figure 70. A scale of tones can be compared to a piano keyboard: we can choose which part of the range we want to use.

22
ANALYSIS OF NATURAL COLOR

The most valuable way to study color is by direct observation and analysis of what's in front of you. The exercises we've considered are only a means to an end: to see more and to translate this vision into the act of painting a picture. Having cleared up a few points about the characteristics of colors, I suggest that you get into the habit of applying this awareness to the colors you see around you in everyday life, while you sit in a train or walk down the street.

In fact, you can start now. Look up from this page and pick out the first color relationship that your eyes focus on. Remember that colors are not perceived separately, but are usually influenced by adjacent colors.

In analyzing natural color, try using, as far as possible, the categories discussed earlier; of these, tone and temperature (warmth or coolness) are perhaps the most important. Fig. 71 illustrates one way in which you can develop your awareness of color relationships. The tone of each color area is numbered from 1-5. The neutral, comparatively colorless areas have been analyzed in exactly the same way as the more positive ones—no gaps have been left. Intensity has been noted only when it seemed relevant to do so.

In order to study color, it isn't necessary, of course, to put everything down on paper. At odd times you may find yourself staring at a bit of floor, perhaps, or at someone's coat, and thinking: "Is this a warm gray in relation to that white? A little brownish? Is the red a shade lighter than the buff wall behind it?", and so on. This kind of rumination is also a valid way of sharpening your perception of color relationships.

Another useful experiment is to paint as many different colors as you can find in, for instance, a flower —without actually painting the flower. Put down the colors in solid touches, mixing each hue separately, as carefully as you did the color squares. As far as you can, relate the size of each color patch to the amount of that color in the subject.

The purpose of this experiment is to help you to think of a gradation (say, from white to pink) in terms of the colors that it's composed of. In this respect, the exercise can be compared to the way we considered a curved plane as a series of small flat ones (Fig. 41).

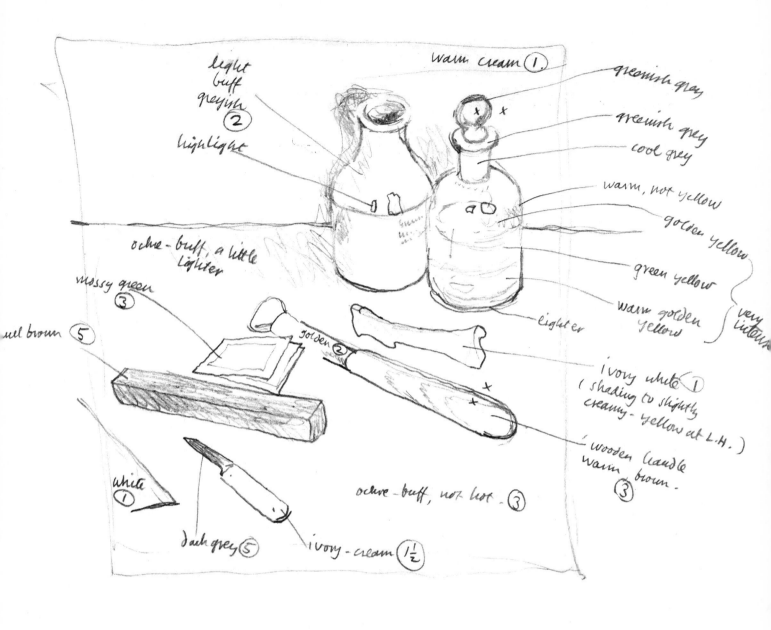

Figure 71. *A drawing made with careful analytical notes of color values. These are made as descriptive as possible. The numbers refer to a range of tones ranging from 1 (lightest) to 5 (darkest).*

23

OBSERVED
AND INVENTED
COLORS

I doubt if any color in a picture can be said to be completely "invented." When successful, it has almost always been taken from some memory of previously observed color. The hue is often an intensification of a color in nature which is almost invisible to anyone but an artist. Even when the Impressionists' color vision has become part of our normal way of seeing, a painter will perceive many more subtleties, such as bluish or violet shadows, than ordinary people will.

Even the flat, suffused fields of color of abstract painters such as Rothko may to some extent owe their power to the phenomenon of the "after image"—the glowing and unexpected colors we see when we close our eyes after looking at a bright area.

Bonnard, Matisse, and Klee, to name three of the greatest colorists of modern times, retain even in their most inventive and extreme color a living connection with things seen and experienced. When invented color loses contact with experience, it becomes merely arbitrary. If this arbitrary color retains its charm, we tend to call it "decorative." Mindless intensification of color, what I call "pepping up," can easily lead to the kind of unfortunate results on view in many an exhibition. I've always felt that Gauguin was responsible for a vast amount of bad painting and

merely pepped-up color when he made his famous—and extremely dubious—remark about a yard of green being greener than an inch of green; or when he advised: "You see this as rather bluish? Right! Then put down the purest blue you have."

Fortunately, Bonnard did not follow the advice of the great colorist. Instead of merely exaggerating color—which is where Gauguin's advice leads—he continued with ever-increasing daring and freedom to embellish the harmonies he found all around him. Color Plate 10 reproduces a very good example of Bonnard's ability to take a relatively commonplace harmony, and to find in it the new, the unexpected, and the subtle. This particular view of St. Tropez that the artist chose is commonplace. But Bonnard has perceived and captured what would pass unnoticed by the average painter. His color, a simple blue, green, and yellow relationship, in less competent hands might have resulted in a pleasant but banal picture; but see how he has spun a web of subtle variations through the sky and foreground, leaving the central strip of green trees relatively plain in color. The blue sky and sea continuously gradate towards greenish, pinkish, or violet hues, and then change gradually back again to pure blue.

The foreground of *St. Tropez* is a lesson in how to extract pattern and tapestry-like color variation from a comparatively featureless expanse. A less sensitive artist might have merely brushed in this area as a bit of foreground, necessary perhaps to the design of the picture but of no great interest. Curious emeralds, pale blue-greens, and soft pinks play and flicker against the generally yellow tone of the grass. The shapes of the upright blue-white stalks are loose and wandering, but are nonetheless placed precisely. The red-brown dollop, the darkest accent in the foreground, is perfectly positioned to create a "stop" in the otherwise undifferentiated movement of this area.

I'm afraid I can't suggest any experiments that you can make in this particular field; the only advice I can give is to recommend that you paint and paint, trying as you do so to avoid falling into mechanical habits.

These habits can be dangerous. As we go on painting, we tend to rely on certain color mixtures that we know work for certain situations. This tendency to some extent is inevitable; but it should not prevent us from looking intently at what we're painting, nor stop us from experimenting with new subjects and color combinations all the time.

24

COLOR AND

TONE

Good color often depends on tone. Color and tone, in fact, are practically inseparable, even though attempts have been made to treat color as if it existed independently. For instance, it has often been said that Cézanne relied on color changes instead of tonal modeling to render solid form. In a sense this observation is true, because Cézanne saw that each plane, as it turned away from the light, became a different color; but the tonal changes are there as well, though closely related. If they weren't, a monochrome photograph of a Cézanne still life would be quite meaningless, whereas it still looks magnificent when reduced to black, white, and gray. The same can be said of Bonnard and Matisse, who both relied even more than Cézanne on color organization.

Fig. 72 reproduces in black and white a picture which could be said to rely heavily on its particularly beautiful color. Tonally, as you can see, it still makes a very satisfying design.

Bad or muddy color can often be traced to tone that doesn't work. Students painting a head often have great trouble with the color of the light shadows in the flesh, and blame muddy color on the actual mixtures they are using; whereas if the tone is balanced with a real sense of relationship, the color will probably work. It is possible to make quite unrealistic color look convincing—or to make "accurate" color look terrible—by the handling of tone.

I should say here, in parentheses, that good tone isn't only a matter of making sure that nothing is "out of tone," any more than being a good musician depends on playing no wrong notes. Tonal mastery is by far more positive than that. Painting even one passage truly in tone with another is itself a minor creative act, not a question of copying or of playing safe.

Many great colorists, including Van Gogh, Manet, and Velasquez, started their careers as painters with somber, almost monochromatic pictures. So there are good, and impressive, precedents for starting cautiously, for certainly the grasp of tonal pattern, which was necessary for these three painters in their early dark pictures, stood them in good stead after they had lightened their palettes.

You will, I'm sure, learn a valuable lesson about color if you paint a series of small experimental still lifes in which you progress from monochrome to color. Make the first of the series almost monochromatic. Introduce one colored element into the next still life, and so on until the final picture is composed entirely in pure color. You will discover a very important fact about color and tone if you do this experi-

Figure 72. *Henri Matisse: Odalisques. Collection Mr. and Mrs. Ralph F. Colin, New York.*
This Matisse, beautiful as it is in color, still makes a satisfying tonal arrangement when
the color is taken away.

ment: strong color contrasts and strong tonal contrasts don't happily fit together in the same picture. In other words, the more pure color you use, the closer together the tonal changes must come.

This principle applies with particular force when you want to paint tonal changes caused by light and shade falling on a curved surface—an apple, for example (see Fig. 73). If you look for this particular feature in museums and galleries, you will find that strong light-and-dark modeling (Rembrandt, Caravaggio, Leonardo) always accompanies a limited palette; while pure color demands a flatter treatment (Matisse, Indian miniatures, Sienese painting, and to some extent, Cézanne, as I mentioned before).

There is always an unpleasant and overdone quality in a picture which uses strong color as well as strong modeling. Pure color needs open spaces to breathe in.

In the end, you must find out for yourself—and the only way to do that is by painting many pictures. I would go even further and advise you never to take anything for granted about color or believe anything you hear without trying it out for yourself in your own painting!

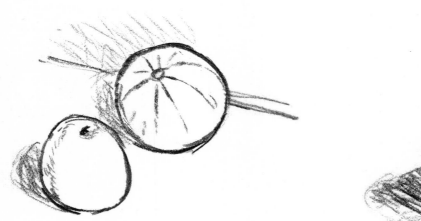
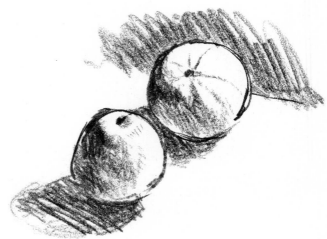

Figure 73. *Intensely colored forms need, on the whole, a minimum of modeling from light to dark. Strong modeling, as in the drawing on the right, is most compatible with a comparatively monochromatic palette.*

25

COLOR AND

LIGHT

What makes one painting look luminous and another appear comparatively dead in color, even when the subject of both is the same? Numerous reasons account for the difference. Tone, discussed in the last section, is one very important reason. Another—a very important one—is the relationship between warm and cool colors. Though a monochrome picture can still be luminous, a painting that offers even the slightest changes from warm to cool will seem to contain a more subtle feeling of light.

I think I should mention another aspect, even though it may be obvious: every patch of color you place on the canvas is meaningful in relationship to its neighbors and deserves close study. It wouldn't be a bad plan for you to try never to place a brushstroke of color unless it "works" positively in relation to the adjacent colors—adds to their impact, rather than just unoffensively fills the space. I think this positive action does, in fact, happen all through a picture like the Bonnard *St. Tropez* (Color Plate 10),and in a less obvious way in the Boudin reproduced in Color Plate 14. This latter has a splendidly luminous and blowy sky, which Boudin almost certainly brushed in at one sitting. Notice how precisely and sensitively the artist has observed the tone and color of the grays. Another painter might have been tempted to exaggerate the contrasts in this sky, possibly making it more dramatic, but also far less true and fresh.

Both Boudin and Bonnard also handle the opposition of cool and warm with great subtlety. Look at the way Bonnard manages changes of color in the blue areas of sky and sea in *St. Tropez*. The sky moves from a cool, pure blue in the central band towards a greenish hue at the top and a pinkish color at the horizon. The pink becomes stronger and warmer in the town; a frank violet is found in the water. Nevertheless, all these variations are enclosed, so to speak, within the context of that beautiful blue. The modulations are made with great discretion, so that no color jumps out of context.

Of course, the color that we see depends entirely on the quality and amount of light that illuminates it. To say that Turner and the Impressionists discovered light as the main subject of a picture is a cliché. In fact, light cannot be apprehended by itself, but perceived only by the way it bounces off the colored planes of the objects that it illuminates.

In the traditional "artist's studio," this illumination is kept constant by restricting it to a cold north light. However valuable a north light is if one has to paint a portrait in a number of sittings, a variety of illumina-

tion affords a good way of learning something about the effect light has on color. So there are potential advantages in the apparent disadvantage of not having a properly illuminated studio. Almost any room in the house can be useful for studying light and color!

Because of its combination of artificial light and daylight, my picture called *Snowy Morning* (Color Plate 13) could not have been conceived in a traditional studio, but only in a particular room at a particular time of the year. Here, daylight is reflected off fresh snow through a low, small cottage window so that it is both strongly colored (cool and bluish) and strongly directional (from low down). The figure is thus seen as a cool area of color in silhouette against the very warm area of light cast by the lamp. This large division of cool areas against warm areas— whether formed by the effect of light or by local color —is well worth exploring.

Composition, often approached as a separate element that can be analyzed and studied apart from other considerations, actually follows from the painter's involvement in his subject matter. The following sections will not, therefore, contain lessons on "how to compose." A picture ought to compose itself and find its own form, which cannot be divorced from its content. However, an artist can become aware of various composition or design possibilities. The conscious study of these possibilities by experimenting with various exercises and by looking intelligently at existing pictures has a delayed reaction and probably becomes most useful when this knowledge has sunk to the subconscious level, where it acts as fuel.

I prefer the word "structure" to the word "composition," which implies, for me, moving existing units until they take their rightful place in the picture. This kind of arranging happens, certainly, but it suggests a slightly mechanical concept. I prefer to think that a picture is built as a total structure—or better, that it grows like a living organism. The distinction is similar to that of moving furniture around as compared to building a house. More than this: a picture is about something before it finds the form that embodies this content. Yet this very form inevitably alters the original content, so that, finally, there is no distinction between the two.

We're concerned with no more than an attempt to break through inhibiting clichés about picture-making, and to open our eyes and minds to new approaches. Specific exercises will be suggested where they are called for. In general, however, Part Three will focus on looking at pictures. You'll have to find your own ways to apply the ideas that you absorb.

26

INVOLVEMENT WITH THE SUBJECT

Potential painting subjects are all around us. A figurative painter need not spend much time looking for things to paint if he keeps his eyes open. He's more likely to be concerned with selecting what he wants from a bewildering variety of possible starting points.

Critics writing about abstract art often use expressions such as, "Now that the painter is free from the need to represent nature . . .", as if representation in itself was totally limiting and constricting. I have always felt that the reverse is true: that it's often the abstract painter who's limited by his own inventive powers to the extent that his forms and colors are repetitive and meager. By contrast, awareness of visible forms—itself inexhaustible—is expanded ever further by the emotional overtones that the artist associates with almost any natural subject.

Still, everyone has his own strong likes and dislikes —some subjects mean a lot to us, others leave us indifferent. It's essential to develop these preferences; develop them, that is to say, through experience. This, however, is not at all the same thing as merely accepting preconceived ideas about what subjects are possible or not. At the beginning, when we're making the first steps towards an understanding of painting, it's a very good thing to keep as open a mind as possible; for almost anything we see and experience can be the starting point for a painting.

Once you've chosen a subject, try to let it dictate the form that the picture takes. By this, I mean that your intense involvement with the subject and your ability to concentrate on its nature are infinitely more important than fitting it into a compositional mold or following traditional "rules."

27
SELECTION OF THE MOTIF: USING WHAT'S THERE

Choosing a motif from the chaos and clutter of the visual material that surrounds us is, obviously, the essential decision in all painting based on nature. What is not always appreciated, though, is that once you've made this choice, you'll probably have a greater chance of creating an interesting design if you accept all the accidental oddities that your motif contains, instead of trying to tidy it up by leaving out elements which seem unessential or tricky to handle.

Many amateurs' pictures suffer from a tendency to leave out too much. Sometimes this is done, arbitrarily, for negative reasons—because the painter thinks that he doesn't like an element in the material he has chosen. I've seen a painter, trying to deal with a rather complex mass of boats and rigging near a harbor, leave out a black shed against which parts of the hulls were silhouetted for no better reason than that she felt it was an "ugly" shed. Doubtless, she wouldn't have wanted that particular shed in her own garden; but it was, in fact, an essential part of the motif she had chosen. By leaving it out of her picture, she gave herself an insuperable problem: she left a blank on her canvas which her powers of invention were inadequate to fill.

The leaving out of things is not limited to landscape subjects. For example, in painting a portrait against an ordinary studio background, many amateurs will go to great lengths to ignore the odd shapes made by such objects as radiators. The students' paintings (Figs. 114-118) illustrate how such elements can be used constructively.

The painting by Vuillard reproduced in Fig. 74 offers a beautiful example of the use of "what's there." It doesn't matter in the least that some of the shapes are so ambiguous that you can't put a name to them. The desire to label everything in a picture— this is a tree, that is a fence, and that is a house—can be a very limiting approach to selecting a motif. Don't forget that leaving out invariably means making blanks, which your imagination or memory will then have to fill. Most painters, experienced ones as well as beginners, aren't nearly as ingenious as the accidental effects of nature at producing formal relationships that are lively and interesting.

Fig. 75 is a quick sketch of a few accidental shapes that were in front of me while I was typing these words. I drew them purely in terms of the character of their shapes, not bothering about what objects they stood for. I'm quite sure that my own imagination would have produced far less varied results.

Here's an exercise which may help you see the pos-

Figure 74. *Edouard Vuillard:* Conversation sous la Lampe. *Courtesy Lefevre Gallery, London. We can be fairly sure that Vuillard took this scene much as he found it; having found the viewpoint he wanted, he would not have needed to move anything about or leave anything out. (Photo courtesy Messrs. Reid and Lefevre.)*

sibilities all around you—literally under your feet—and how they link up with this business of choice and accident. Look around you for any old, battered, or marked surface—a floor, a paint-stained studio chair or easel—and pick out some smudges, stains, and marks. Make a careful drawing, about the same size as the original of these "accidental" forms (Fig. 76).

Now see what happens if you enlarge this; simplifying it and keeping the essential shapes, but preserving the variety and character of the original (Fig. 77). I think you'll find that the result has a vigor that would be very difficult to invent.

Figure 75. *These shapes, isolated for their character, were selected at random from objects lying about on the worktable. It would be difficult to invent such variety as this.*

Figure 76. *A study of an accidental stain on the floor. Again, it would be difficult to invent such variety as this.*

Figure 77. *In this drawing, a portion of the stain in Fig. 76 has been isolated and enlarged. It has been related to a rectangular surrounding border and the shapes have been, to some extent, simplified. Try selecting small portions of varied surfaces like this: use a piece of cardboard with a small rectangle, or window, cut out of it, or the frame of a color slide, to isolate details from their surroundings.*

Color Plate 1: Jane *by Bernard Dunstan. Collection Mrs. David Corsellis. The modeling from light to dark is affected by the actual tone of each area; thus, the light face and hair show more difference between light and dark than do the dark clothes. This difference gives a feeling of breadth and simplicity to the darker areas.*

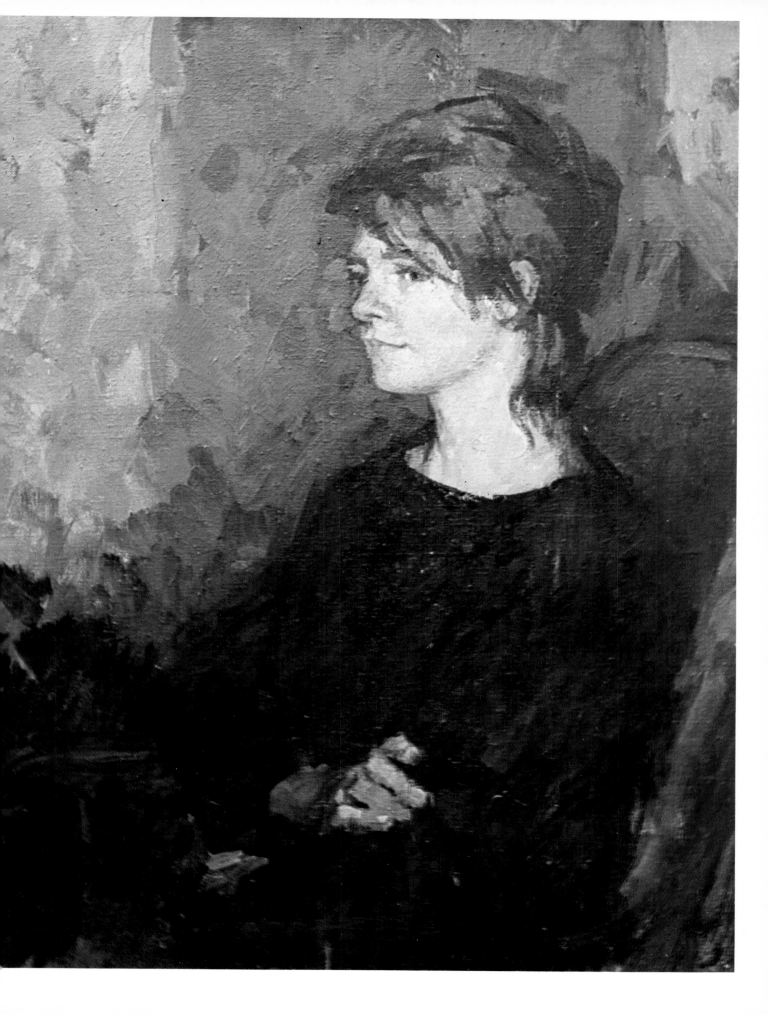

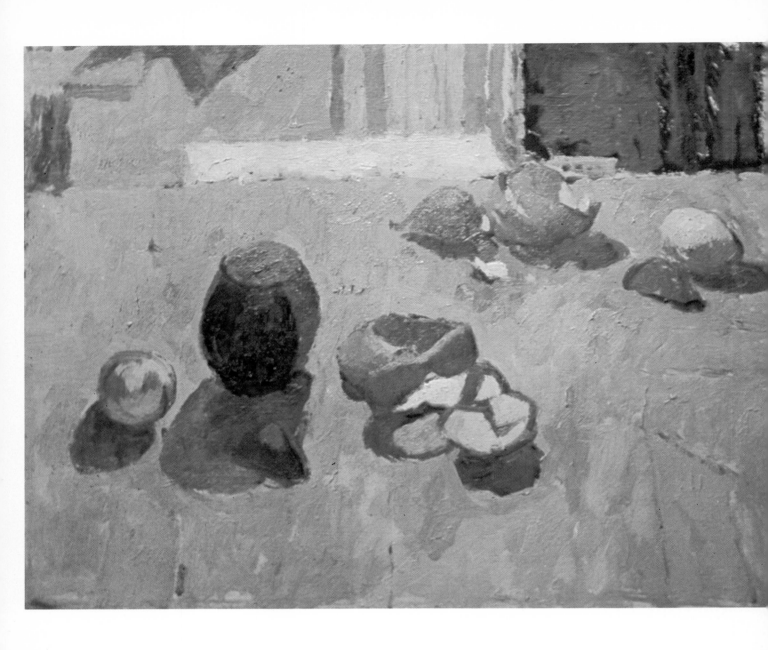

Color Plate 2: Still Life with Tangerine Skin *by Bernard Dunstan. This plate shows the final stage of the still life painting described in Section 13, and was done to illustrate some of the points discussed in Part One. No subject is better than a small still life painted directly from nature for developing your sensitivity to certain essential aspects of painting. Here, the placing, the drawing, and use of negative shapes and spaces were studied with particular care.*

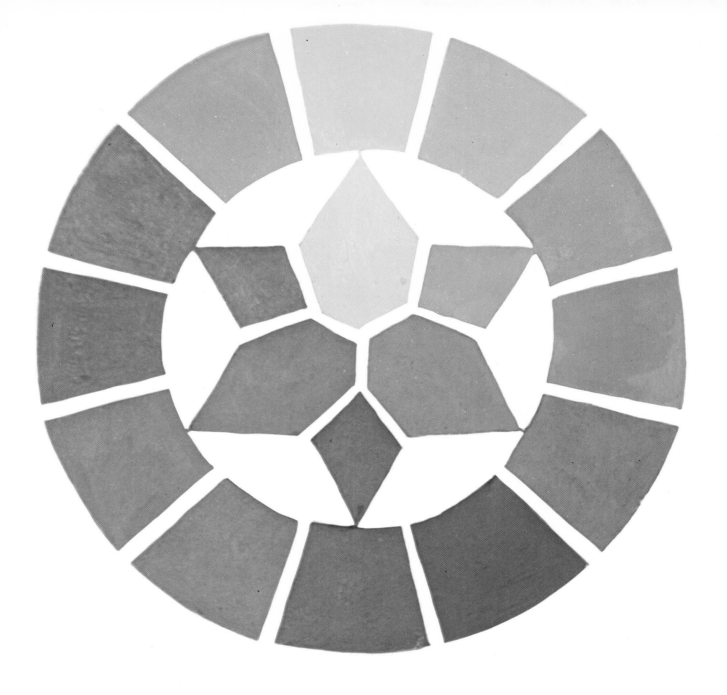

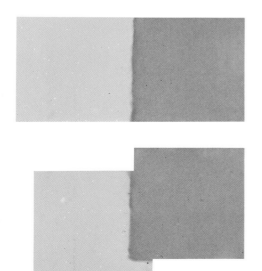

Color Plate 3 : Color Wheel (above). *Notice how the transition from one color to another is made smoothly and without jumps. The value of making a color wheel consists more in the act of carrying out the exercise than in any subsequent use or information it might provide.*

Color Plate 4: Warm and Cool Colors (left). *The idea that "warm colors advance, cool colors recede" cannot be taken too literally. The shapes of the color areas must also be taken into account. For instance, as soon as the blue overlaps the orange, the cool color obviously appears to move in front of the warm one. It would be truer to say that in variants of the same color, the cooler, or grayer, ones tend to recede, assuming that their shape and position allows them to.*

Color Plate 5: The Shower (left) *by Bernard Dunstan.*
Collection D. H. Evans, Esq. Broadly speaking, this picture
is based on three vertical stripes. The largest and emptiest
of these, on the left, contains a small accent of strong
color (the red toward the bottom), which acts as a concen-
trated and important "weight," or anchor, to the more
complex areas of color in the two other stripes. Throughout
the painting, the color is based on a fairly simple
opposition of cool and warm.

Color Plate 6: Zennor Quoit 2 (right) *by Ben Nicholson.*
Courtesy Marlborough Fine Art. As in many of
Nicholson's later abstractions, the color is clearly related
to natural sources—stone, slate, sky.

Color Plate 7: Two Women in a Room (above) by *Edouard Vuillard. Courtesy Roland, Browse and Delbanco. In this distemper painting on paper, muted grays are used with as much decision and enjoyment as if they were pure colors. The beautiful use of tone and the exact adjustment of the subtle degrees of warmth and coldness produce a very rich effect.*

Color Plate 8: Young Woman Wearing a Locket (right) by Gwen John. Collection Mrs. Charles Wrinch. *A very limited range of colors—violets, buffs, and grays of generally low tone—is used by the artist in this beautiful small painting.*

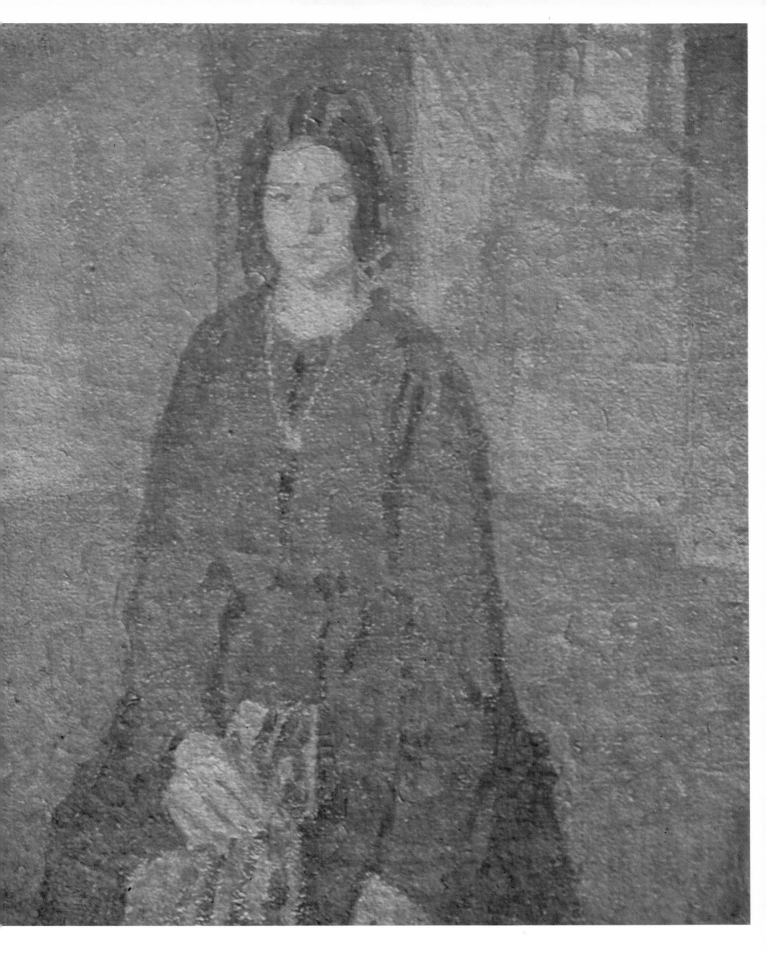

Color Plate 9: St. Jacques, Dieppe (left) *by Walter Richard*
Sickert. Courtesy Roland, Browse and Delbanco. Here
is another small, direct painting with a very limited range
of color. The red-brown of the wooden panel is allowed to
show through all over the surface. Sickert painted a great
number of small panels of this sort in his early years;
they were almost certainly done on the spot, probably with
the panel held in the lid of a small paintbox.

Color Plate 10: St. Tropez (above) *by Pierre Bonnard.*
Courtesy Roland, Browse and Delbanco. Unexpected
subtleties of color are discovered by Bonnard in a relatively
commonplace view.

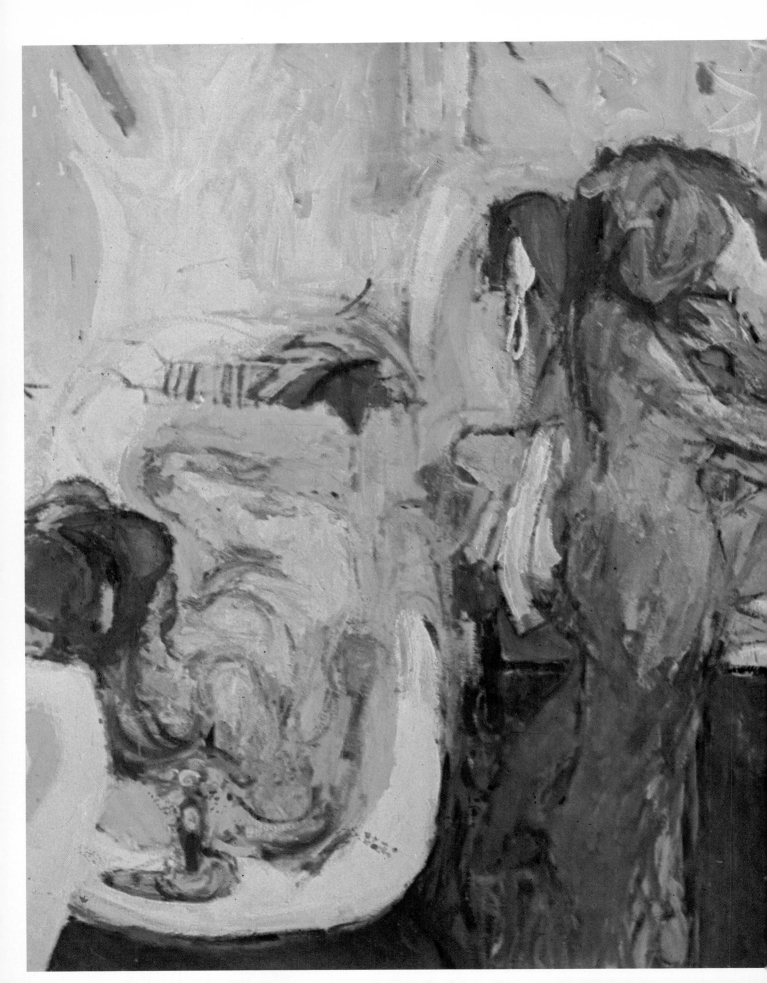

Color Plate 12: Dressmaking *by Bernard Dunstan.*
Collection R. J. P. Barber, Esq. The combination of artificial
light and cold daylight in this painting creates a division
of areas of cool against areas of warm color.

Color Plate 13: Snowy Morning *by Bernard Dunstan. The*
color in this painting is simplified into a single warm-cool
opposition. Within each area of color there are, of course,
a good many subtle changes; but essentially, this is an
orange-blue painting. From the point of view of design,
the fundamental structure is equally simple: a tilted square
within the larger square of the canvas.

Color Plate 11: The Bathroom (left) *by Bernard Dunstan.*
This picture relates to several points brought up in the text.
The color (see Part Two, Section 21) has been generally
intensified, though in no instance has it been transposed
arbitrarily, and great care was taken not to exaggerate the
tonal values. Thus, the pinks, violets, and greens of the
flesh are developments of slight color changes that were
already there. Great care was taken not to exaggerate tonal
contrasts. Compositionally, notice how the strong central
vertical axis (the side of the bath) has been used to divide
the rectangle (see Part Three, Section 33). On each side
there are a number of directions which would, if continued
across this division, meet at right angles—for instance,
the thighs. Such "links" help connect the two sides of the
composition and lock the design together.

Color Plate 14: La Plage de Trouville *by Eugène Boudin.*
Courtesy Roland, Browse and Delbanco. Every color in this
painting is positive; the grays in the sky, for example, are
very exactly observed. It would have been easy to
exaggerate the contrasts here and lose the subtlety of the
contrasts.

Color Plate 15 : Cottage Bedroom *by Bernard Dunstan. This picture, which is on a small scale, depends largely on very exact relationships of similar tones. Note the dark shapes on the left; they are very important to the composition.*

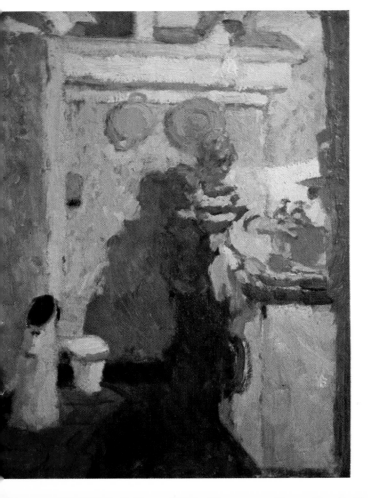

Color Plate 16: The Cottage Kitchen *by Bernard Dunstan. This small painting was started on the spot and finished with the aid of a drawing (Fig. 71), on which I made notes, as described in Section 22, of the colors and tones.*

Color Plate 17: Student's Painting (left). *For a beginner, this is an extraordinarily successful attempt at a very difficult subject. The student here seemed to find it quite natural to paint as if he were looking down on the room. He used, or reassembled, what he knew to be there as well as what he could actually see, in a mixture of conceptual and objective vision. The decorative handling of the floorboards and the richness of color throughout show a born painter.*

Color Plate 18: Transcription after Jan Vermeer's A Lady at the Virginals (right), *using the monochrome collage (Fig. 129) of the same subject as a starting point. It began in purely abstract terms; in fact, I placed both the panel I was painting on and the original collage on their sides to make it easier to see the shapes in them freshly. Later, however, a photograph of the original painting by Vermeer was consulted, and the subject matter made a comeback.*

Color Plate 19: Random Collection of Red Objects (right). *This collection of red objects, scraps of paper, materials, etc., was picked up around the house and put down without too much conscious arrangement. The exercise was done by concentrating as completely as possible on the color relationships between the different kinds of reds. The relative area of each color is also very important, but the shapes have been simplified down to mere patches to give full value to the color differences.*

Color Plate 20: Still Life with Dead Birds *by Kyffin Williams. In this still life painting, the artist used subject matter that obviously had to be painted in a hurry. This was painted straight through in one sitting, from start to finish.*

28
CHOICE OF SUBJECT: LANDSCAPE

Let's pursue this question of arriving at more interesting design by neither selecting nor omitting too much. In dealing with landscape, we're particularly liable to accept design clichés, almost unconsciously leaving out or modifying everything that doesn't fit these conventions. To show how powerful our rigid concept of what a landscape is, draw any irregular, roughly horizontal line across a long rectangle (Fig. 78). This will immediately suggest the idea of "landscape" to almost anyone, from any culture, even though it's nothing more than a completely arbitrary and abstract division of the space into two stripes.

Most of the landscapes we have been brought up with, from Hobbema to Monet, essentially consist of a division between land or sea and sky. This convention is perfectly natural, corresponding to what we see all around us. But this convention is so deeply rooted that it can take over and become *all* that we see when we look at landscape, preventing us from seeing anything else: hence, the innumerable, practically identical landscapes that are turned out every year. These painters, to some extent, have blinkers on that prevent them from fresh discoveries.

Most painters do wear blinkers of some sort, which are sometimes borrowed from other people, and are sometimes homemade. It does no harm to try to pry them off now and again. Beginners, for example, have a tendency, when faced with a complex landscape, to position themselves so that nothing "gets in the way." They will try to establish an unobstructed view that contains as little as possible in the foreground. The distance then makes up the greater part of the interest of the picture (Fig. 79).

This approach is encouraged by both practical and psychological reasons, as well as by painting conventions. From the practical point of view, the beginner doesn't feel equipped to deal with a complex foreground, which he has perhaps been conditioned to think of as "detail" that should be avoided like the plague. From the psychological angle, we all have a desire for uninterrupted space and large vistas, particularly if we live in cramped urban conditions.

Pictorially, it is often hard to deal with small units that lie along the horizon. Large foreground shapes are likely to divide the picture more interestingly, and, in addition, they correspond more closely to what we see. Our vision doesn't necessarily start thirty yards away from our feet—which is the impression that so many landscapes give—but it takes in the whole field of space, from the immediate foreground where we are standing to the distant horizon. We're just as likely

Figure 78. *Any line drawn roughly across a long rectangle immediately suggests the concepts of landscape and horizon.*

Figure 79. *In this view of a landscape, nothing "gets in the way" to obstruct the forms in the distance.*

Figure 80. *From a viewpoint a few steps to the left, the subject introduced in Fig. 79 is completely altered compositionally.*

Figure 81. *In this wash drawing by Kyffin Williams, the verticals made by the posts are very useful in setting up a series of intervals against the other forms in the landscape.*

Figure 82. *These two posts are used to divide the space geometrically.*

Figure 83. *Even the back of an automobile can be used in a composition; it doesn't have to be left out, as is usually the case. The car arrived and was parked after I had started this drawing, preventing me from seeing the towpath behind it; so it seemed reasonable to incorporate it into the composition as best I could.*

Figure 84. *A leaf in the foreground of a picture can be larger than a figure in the distance.*

to see a landscape, such as I have drawn in Fig. 80, as we are to come across a landscape that looks like the one in Fig. 79. The difference between one view and another was, in fact, created by my taking just a few steps. Both are perfectly possible and equally attractive. My point is that we need not always make the obvious choice. In fact, the less conventional choice is often more likely to offer those unexpected qualities that add interest to your painting, whatever its other deficiencies may be.

Many painters carefully leave out objects, such as billboards, posts, or telegraph poles, on the basis that they are "ugly" or "in the way." However, such objects often make useful vertical divisions. The drawing by Kyffin Williams (Fig. 81) shows how useful these verticals can be in setting up a series of intervals across the other forms in the landscape. In Fig. 82, notice how the large post divides the area so that there's a roughly square shape on one side, while the smaller post echoes this division on a reduced scale. (I will deal more fully with ways of dividing rectangles into squares later on.) This simple geometrical structure works successfully against the broken soft shapes of the trees.

As I suggested in the last section, make use of all the objects contained in the view you've chosen; se-lect this viewpoint by walking about and examining all the landscape possibilities, rather than by arbitrarily leaving out objects because of your esthetic and prejudiced preconceptions. Even the back of an automobile—if its shape, tone, and color are observed and designed as part of the picture—will probably add more to your painting than if you left it out and filled the resulting blank from your imagination (Fig. 83).

Another reason that artists avoid foreground shapes is their fear of "detail." Yet there's no reason why a form that is close-up should be painted more precisely than any other part of the picture. When we focus our eyes on the distance, our immediate foreground is blurred. The very same thing can happen in a picture. And don't forget that a leaf in the foreground may actually appear larger than a figure further back (Fig. 84). One can hardly be called a "detail" any more than the other.

The next time you go outside with a sketchbook, make a few drawings in which you allow the foreground to fill over half the area. Use the shapes which come up to within a few feet of you. Conquer any fear of detail by observing and drawing these forms as simply as you did in the exercises in Part One of this book. You may find these experiments open up a whole new area of subject matter.

29

SELECTION: MAKING LESS DO MORE

No one could possibly paint everything that falls within his whole field of vision. As artists, we're obliged to select only a small part of what we see. Some have made a practice of looking at their subject through their cupped hands, or even through a frame cut from a piece of cardboard.

Let's take this basic principle of selection one stage further and proceed, step by step, to see how less and less of an actual motif can be made to do more and more in your picture space.

First, put any simple combination of silhouetted shapes together in a rectangle frame. The result will look something like Fig. 85A, in which the shapes float in the middle, surrounded by white space. Now proceed by reducing the size of the outer frame, which will correspondingly enlarge the enclosed part of the motif in relation to its surroundings. The first change that occurs (Fig. 85B) is that the shapes no longer float; they touch or cross the edges. Furthermore, the white area, instead of appearing as a continuous background, itself becomes separated into shapes (Fig. 85C). As the process of enlarging an ever-decreasing area continues, these white shapes become more important. In Fig. 85D, we can "read" the design either as white on black or as black on white.

The exercise we have just carried out illustrates in a simple, abstract way what happens when we compose a picture from things seen. We not only enlarge the shapes, we also radically alter their character by this "closing-in" procedure.

Now take any landscape, such as the one reproduced in Fig. 86, which presents a perfectly commonplace scene. To show that the "abstract" you just completed was not so far from reality, look at the shapes made in Fig. 87 (left) by the sky between the trees. These are just as "abstract" as the previous illustrations. Moreover, you can see that just as big a change in their character occurs when they are blown up (Fig. 87, right). In other words, a slice of the cake is by no means the same shape as the cake. Out of this one large scene, it is possible to make several self-contained small pictures, each of which has a completely different character (Fig. 88).

This possibly obvious comment leads us to an important point: the average "view" is quite likely to contain enough material for several pictures—which is not necessarily a defect. After all, some of the greatest pictures in the world—by Brueghel, for instance, Poussin or Rubens (Fig. 89)—overflow with enough material to keep lesser artists busy for years. And there's quite enough going on in Tintoretto's San

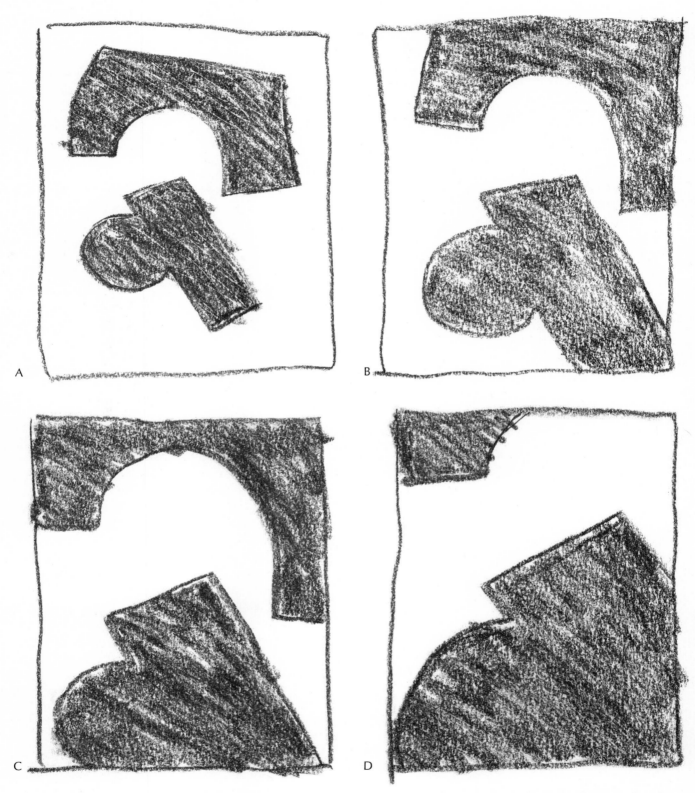

Figure 85. *Silhouetted shapes "float" in white space (a). Enlarge the shapes so that they touch the edges; the white area, instead of being merely a background, itself becomes separated into shapes (b). A further enlargement makes the white shapes even more important (c). Finally, the design can be thought of as either white on black or as black on white (d).*

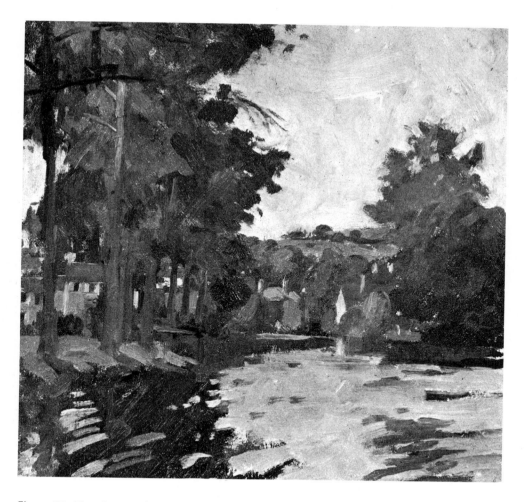

Figure 86. *Here is an ordinary enough scene in which, nonetheless, many abstract shapes can be found.*

Figure 87. *The study (left) of the shapes of the sky as seen between trees was taken from the painting in Fig. 86. To the right, the same shapes have been enlarged.*

Figure 88. *Several small compositions could be made by enlarging fragments of a complete picture.*

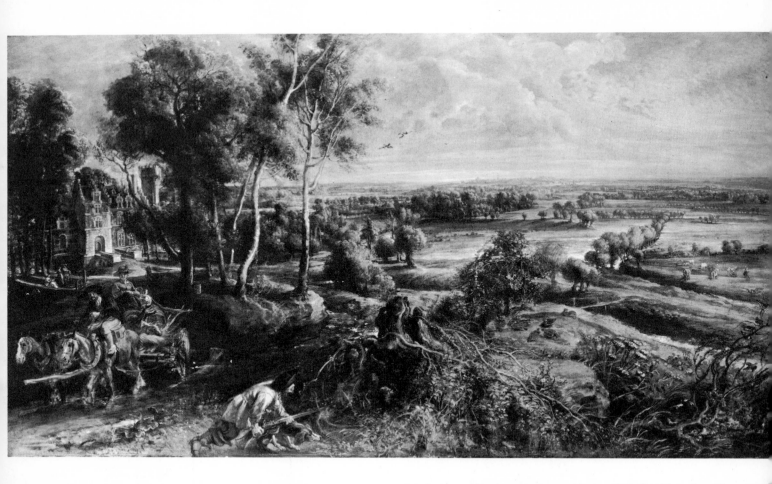

Figure 89. *Peter Paul Rubens:* Le Chateau de Steen. *National Gallery, London. The grand scale of this landscape contains so much material that literally dozens of other, smaller pictures could be made out of it.*

Rocco *Crucifixion* to keep twenty painters occupied. On the other hand, the parts of a great Cézanne painting (Fig. 90) are welded indissolubly into the whole so that nothing can be taken away. So this is not a value judgment.

Still, it may be worth taking a look at some of your pictures, even mask off certain areas with pieces of paper, to see if you haven't missed the essential point and buried your real motif behind a lot of padding.

How little material one needs to make a picture is a point well illustrated by the following anecdote. Corot was out painting one day when he was approached by a bystander, who said: "Excuse me, but I've been watching you paint, and do you know I can't understand what you're up to. Your picture doesn't seem to be a bit like this landscape." Corot pointed with his brush; there, tucked away in the distance of the impressive landscape, with its rolling hills and great trees, was a tiny bit of someone's backyard, a couple of bushes, a gate—all the artist needed.

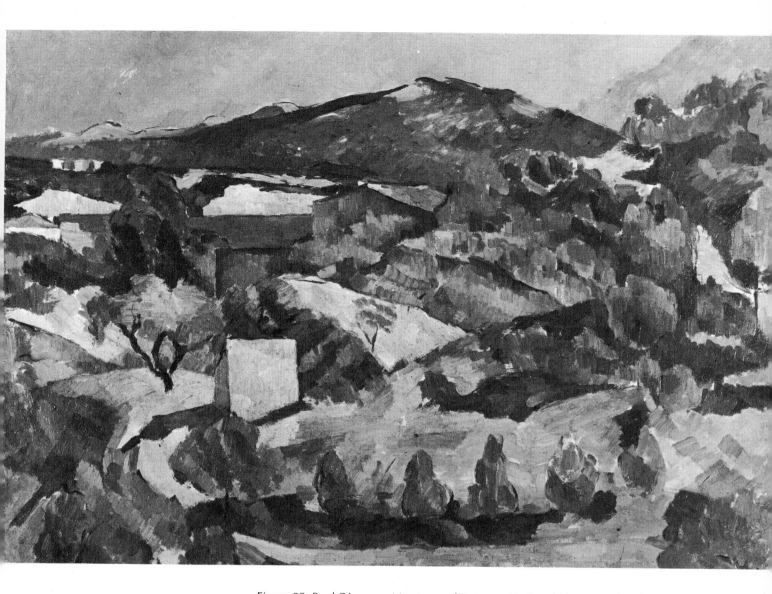

Figure 90. *Paul Cézanne:* Montagnes l'Estaque. *National Museum of Wales. In contrast to the Rubens in Fig. 89, this painting is totally self-contained; it would be difficult indeed to take anything away from it.*

30

THE SHAPE
OF THE
PICTURE

No picture can possibly exist without a shape, the area within which it works. According to need and function, pictures have been painted which are oval, circular, semicircular, diamond-shaped, and hexagonal. Still, the most common area in which we set forms and colors to work is the rectangle; therefore, we'll start from that shape.

An artist's pictorial concept unconsciously becomes adjusted to and modified by shape. That is, many pictures develop along certain lines simply because of the size and proportion of the canvas that the painter happened to have ready at the time. Sometimes, indeed, the canvas can be a bed of Procrustes into which a picture is forced that would be happier in another format.

In other pictures, the proportions of the canvas are taken for granted, the forms being arranged within the rectangle more or less comfortably, without much thought being given to the matter.

Many painters prefer to start from a given canvas shape. Chaim Soutine (Fig. 91), for example, used to buy worthless second-hand pictures on which to paint, placing his subject within this ready-made rectangle sensitively and with great certainty. Beginners, however, would do well to develop an awareness of format instead of relying solely on the standard proportions of commercial canvases and boards. If you prepare your own hardboard panels, you can easily cut them any shape you want. The standard sizes— 20" x 24" or 28" x 36"—can become slightly tyrannical if you get into the habit of making all your pictures in these proportions. And, of course, you can stretch your own canvas in whatever dimensions you prefer.

A picture can start without any definite shape, growing outward, so to speak, until it finds its format (Fig. 92). Try this approach. Choose any subject that interests you and start at the point which interests you most. For example, a head might be your focal point. From this—or any other focus—draw outward, piece by piece. Stop whenever you find yourself losing interest and drawing mechanically. Go back to your center and work outward in another direction. When you see the shape emerging, begin to mark off a tentative rectangle.

Now you have an example of a composition whose

Figure 91. *Chaim Soutine:* Woman in Red. *Collection Dr. and Mrs. Harry Bakwin, New York. The relationship of form to the canvas format is extremely sensitive; one can almost feel the forms being affected, pushed this way and that, by the pressure of the outside edges against them.*

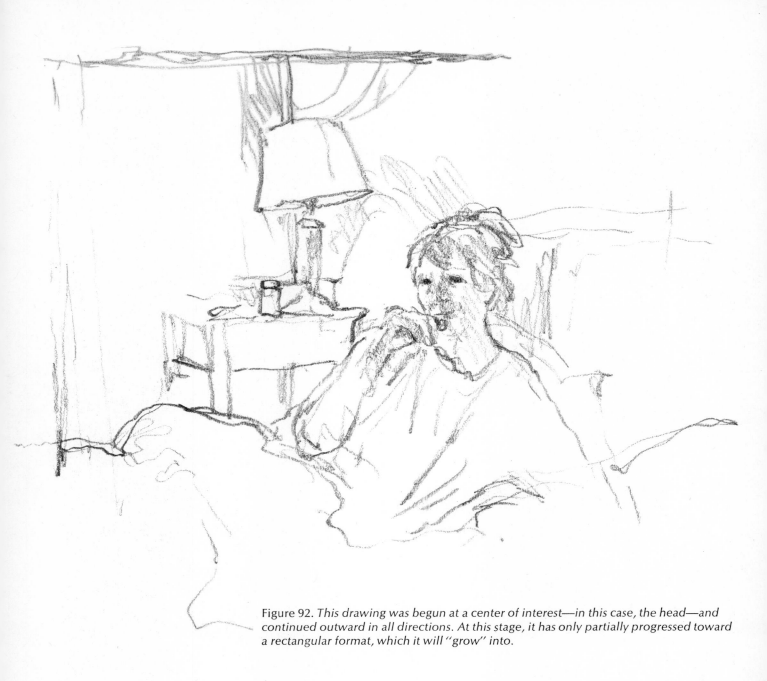

Figure 92. *This drawing was begun at a center of interest—in this case, the head—and continued outward in all directions. At this stage, it has only partially progressed toward a rectangular format, which it will "grow" into.*

Figure 93. *A drawing can be worked outward from a center to establish its outer shape (left); or it can be worked inward, using its outer shape as a starting point (right).*

shape entirely depends on the way the subject engrossed you, one which grew from a central point and moved outward. This approach offers a marked contrast to the predetermined and more usual method (which, I might add, is equally valid) that begins with a set of proportions (Fig. 93).

When you're making studies, it's easy to become dominated by the proportions of the sketchbook you're using. To avoid this it's most useful to work on a reasonably sized sheet and draw well within it, so that you can develop the drawing into any shape. This advice particularly applies if you're making notes for pictures, because, in this case, you need plenty of room in which to expand your ideas and try out different approaches. Fig. 94 shows a page from a student's sketchbook which makes this point clear.

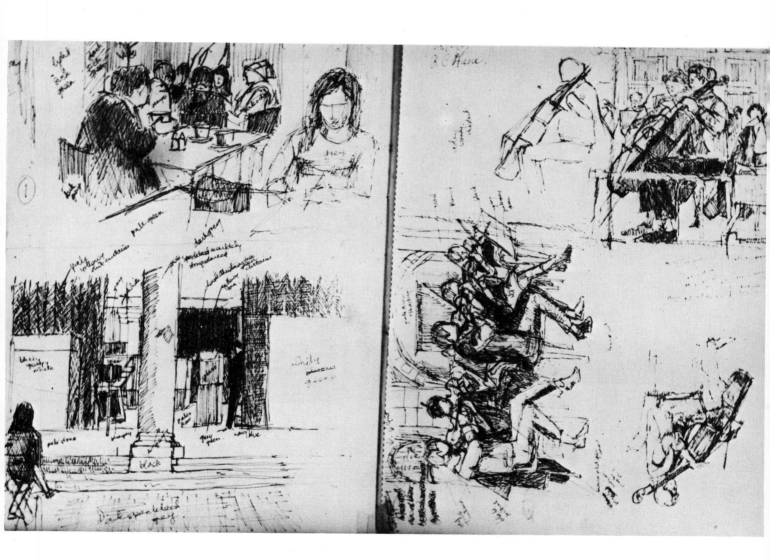

Figure 94. *In this page from a student's notebook, several drawings have been considered, each in relation to its own rectangular "frame."*

31

SHAPES AND
NEGATIVE SHAPES
AGAIN

I've already mentioned (Section 6) the importance of shapes, the spaces between forms, as well as the forms themselves. The disposition and character of these "solid" and "empty" elements are equally important in drawing.

I can't resist including a picture by the eighteenth-century British painter, George Stubbs, as an example (Fig. 95). The forms in this painting are spread out across the canvas like a frieze. Obviously, the flatter the picture space the more possible it is to "read" the picture from one side to the other and to enjoy, piece by piece, the quality of the silhouettes and spaces.

Note, for instance, the silhouette of the horse at the left. From its tail (itself a beautiful shape) to its nose, it provides a superbly organized line. The transitions from curved to straight sections are extraordinarily strong and delicate. A series of beautiful "background" shapes clusters around the horse's head.

Look at the space of sky on the left, between the man's cocked hat and arm, and the horse's nose. This hat is a key shape in the picture: its generous curve can be said to echo, or "rhyme" with, several other shapes—the horse's neck and the curved top of the phaeton, for example.

A curious point about this picture is the way some shapes exactly "touch" others. The nose of the middle horse meets the top of the wheel, while the dog's nose and paws exactly correspond to the width of the wheel lower down. Stubbs often uses this curious device, as though he wanted to reinforce the two-dimensionality of the picture, to state again that the canvas is, after all, a flat surface. Stubbs, because of this, creates a tension between this flatness and the solid forms of his objects, which are modeled just enough to give them the necessary amount of relief. This is very important, because if the forms were more "solid," they would push awkwardly against one another and destroy the exact balance of shapes in this frieze-like design.

In a picture with a deeper three dimensional space, a painting by Rubens, for example, this way of designing shapes so that they just touch would be impossible to handle. The forms would either have to overlap or be kept well out of each other's way.

Figure 95. *George Stubbs:* The Prince of Wales' Phaeton. *H. M. Queen Elizabeth II. The forms in this picture are spread out in a flat, frieze-like way; the silhouettes are of great importance. Look at the transitions from curved to straight lines, as well as the shapes of the spaces left between the forms.*

32
SYMMETRY, CENTERS, AND SPACES

One of the fixed ideas about composition that many people retain, possibly from their student days, is that no important forms should be placed in the middle of a picture. Behind this rule lies the assumption that a form so positioned breaks the design into two symmetrical halves, which, presumably, is a bad thing.

This point of view is a very good example of a precept which every painter has to re-examine for himself, instead of taking for granted. There is no such thing as a hard and fast "rule" in art.

Figs. 96 and 97 show two paintings organized around completely symmetrical placing. Both these pictures portray religious subjects, to which the symmetrical arrangement gives a suitably calm and hieratic solemnity. Andrea Mantegna and Antonello da Messina positioned their main subjects exactly on the central vertical division of the rectangle, grouping the other figures to create an almost equal balance on either side of this axis. Even the attitudes of the attendant figures are similar. In the Mantegna (Fig. 96), each of the two saints puts his weight on one leg; in the Antonello (Fig. 97), the mourners create symmetrical arcs which run through their arms and heads. It is, of course, the little movements away from the symmetrical placement that provide the necessary variety, and so become far more noticeable and important.

These two pictures certainly call into question the rather widespread tendency to discourage the use of symmetrical composition. It might be interesting to execute a series of small compositions from nature or from life, each of which contradicts an axiom of this kind. Think of all the things you were told at school not to do, and *do* them! You might make a start with this "two-halves" idea.

The other consideration that rule-makers ignore is that the placement of shapes is modified and its emphasis changed by many factors: the massing of tone, color, and the amount of accent or strength given to various parts of the surface. All these factors can do as much as placement to direct attention towards a particular area of the picture.

The explanatory diagrams used to analyze composition are usually drawn in line, which, of course, makes everything look more equal in emphasis than it actually is. To show you just how deceiving this can

Figure 96. *Andrea Mantegna:* Virgin and Child with Saints. *National Gallery, London. The symmetry of this composition helps to give it a feeling of stability and grandeur.*

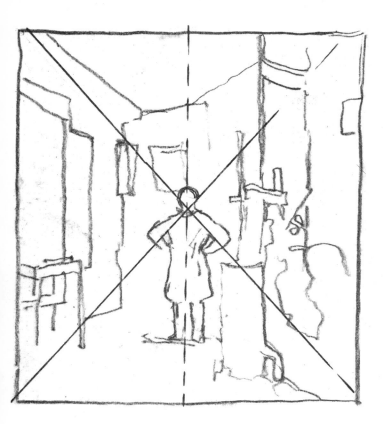 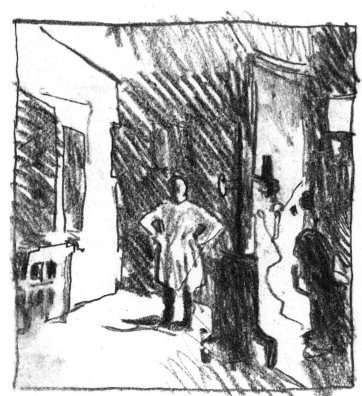

Figure 98. *In this linear drawing after Edouard Vuillard's portrait,* Dr. Viau in His Surgery, *notice how the figure is contained exactly in the center of the canvas.*

Figure 99. *Here, tonal masses have been added to the drawing begun in Fig. 98. The symmetry so evident in the linear version is radically altered, showing how important it is not to think too rigidly in terms of line.*

Figure 97. *Antonello da Messina:* The Crucifixion. *National Gallery, London. Notice the big curves which run symmetrically through the mourners' arms and heads.*

Figure 100. *George Stubbs:* Gimcrack. *Collection Major Sir. R. Macdonald-Buchanan K.C.V.O. This picture is basically a double square; Stubbs, partly by keeping the two sides very different, creates an ambiguity about where the center really is.*

Figure 101. *This sketch of the design of* Gimcrack *shows the placement of important forms within a double square.*

Figure 102. *Canaletto:* View of Whitehall. *Collection the Duke of Buccleuch and Queensbury. Notice how the converging lines in the foreground lead to the center; the little house, however, is slightly off-center.*

Figure 103. *In this drawing of Canaletto's* View of Whitehall, *you can see how sensitively the length of the horizon is divided by the recurring verticals. We tend to "read" a picture from left to right, particularly when it has a long, frieze-like shape, and vertical "pauses" along a horizontal are thus often very telling.*

be, let's analyze Vuillard's fine portrait of Dr. Viau—possibly the only time a dentist at work has been the subject of a picture. If this painting is reduced to linear terms (Fig. 98), the figure fills the exact center of the canvas; the doctor's head, in fact, is placed precisely at the intersection of the two diagonals.

Quite clearly Vuillard, who was as conscious a designer as Degas, did this on purpose. But as soon as we see how this design is subtly altered by the addition of the tonal masses (Fig. 99), it becomes clear that linear placement is only half the story. The big dark masses of the chair and stand now create a pull over to the right, and the broken, varied shapes and silhouettes effectively prevent any feeling of monotony. This is partly what designing a picture is all about: the prevention of monotony by giving the eye a varied diet, so that it continually receives fresh stimuli as it moves over and around the picture area. In addition to variety, the eye also craves order and unity, which is the point of Vuillard's precisely central placement of his figure.

Gimcrack by George Stubbs (Fig. 100) and *View of Whitehall* by Canaletto (Fig. 101) are both great paintings. Notice that the proportions of both pictures are very similar: in both cases, their length is twice their width. Moreover, in one picture (the Stubbs), an important part of the design is placed in the middle, while in the other picture (the Canaletto), all the main lines of the design converge on a point very near the center. One might expect formats as geometrical as these to be particularly susceptible to "falling into two halves." Yet, in spite of their central emphasis, neither of these pictures does this. This, of course, is partly due to the tonal factor we discussed in relation to the Vuillard, but there are other contributing factors as well.

First, look at the painting by Stubbs. Judging by eye, you might think the little square building is in the exact center; but if you measure with a ruler you'll find that the standing jockey is actually in the middle (Fig. 102). Stubbs has created an ambiguity in the composition: one is not quite sure where the center is. The jockey is darker and stronger than the house behind him; on the other hand, the house is bigger as · an area, though the two are exactly the same height.

The placement of the big house on the left shifts the weight strongly to that side. Stubbs has taken the most regular format possible (apart from an exact square), divided the area into two parts, and then proceeded to make the two sides so different that he tricks our eye. This playing with visual ambiguities is an aspect of picture-making that is rarely—if ever—mentioned in art books, which are more likely to treat design as a mechanical, cut and dried affair.

Canaletto has also placed his point of interest just off center; but all his foreground lines lead to the center, converging just to the right of the building (Fig. 103). An ingenious touch is the way Canaletto gives the wall in the middle a series of kinks which break up the rigid diagonal, producing, instead, a number of verticals that echo the vertical of the building behind them. Of course, the wall may have been exactly as the artist painted it; if so, its peculiarities have been seized and used to full advantage—which is itself a creative act.

Both these pictures are superb in their definition of space. Notice how both use a large area of practically blank sky. Neither painter was tempted to "break up" this empty space; each knew its value as a contrast to the complexity of the rest of the composition.

Another design aspect that gives both pictures interesting structural variety is the way the horizon line is divided by the main shapes, and particularly, by the vertical divisions. The spacing of these divisions is specially important in a long horizontal picture space. We all tend to "read" across a long rectangle—to go from one side to the other or to jump into the middle and then read to the left and to the right. The width of the gaps that the eye runs across can create a rhythmic progression which can be compared to a musical phrase.

Try making a picture within the shape of the double square, using the factors discussed in this section. Pay special attention to the placement of divisions and intervals across the picture area. Any scene in any room should yield many suitable subjects. Rather than working from imagination, it's always better to look around and use the material at hand, and to see how it fits—or can be made to fit—the idea you are exploring at the moment.

33

THE GEOMETRY
OF A PICTURE

Certain Italian Renaissance painters, such as Piero della Francesca and Paolo Uccello, were almost as much mathematicians as they were painters. Their researches into the then newborn science of perspective, and their discovery or rediscovery of mathematical ways of organizing and dividing the picture space must have been undertaken with the same passion and excitement of a new vision, comparable to the impact of impressionist ideas in the nineteenth century or of non-figurative painting in our own time.

New and fascinating discoveries in the arts become fossilized into rigid principles, academic formulas; these ideas become over-simplified, taken for granted, and finally misunderstood. For example, by the seventeenth century, academic painters conventionally used perspective and geometry as an accepted method of picture-building. The same happened to Impressionism. And in our own time, abstract art is becoming the new academicism.

A picture like the *Adoration of the Shepherds* (Fig. 104), painted in the seventeenth century by an unknown member of the Seville school, is a good example of how academic formulas can be given new life. If the artist had not been a good one, the picture would have been merely well constructed. However, the formulas are used to construct an extremely complex and satisfying framework within which his compassionate and tender vision expands. A framework of the right kind, used sensitively, is not rigid; it can, in fact, allow emotion to flow more freely, but in an ordered and concentrated way.

The classically ordered arrangement of shapes in this picture was clearly the right structure for this artist's purpose. But without the human and painterly qualities that animate it, the framework would be no more than dry bones. Of course, the "emotion" and the form of a picture cannot be separated quite this neatly, as if they were two separate ingredients which have only to be mixed together to form the right compound. The feeling that this Spanish artist had for people cannot be dissociated from the painterly relish with which he evolves marvelous shapes, such as the shadow on the old lady's head and neck in the middle of the canvas, or the silhouette of the basket of birds on the girl's head. One quality generates the other, and to think they can ever be separated is *the* great academic fallacy.

However, it may be useful to investigate some of the mathematical devices at work in this picture. Notice that the group of figures is arranged roughly in a triangle (Fig. 105), the apex of which is the head of

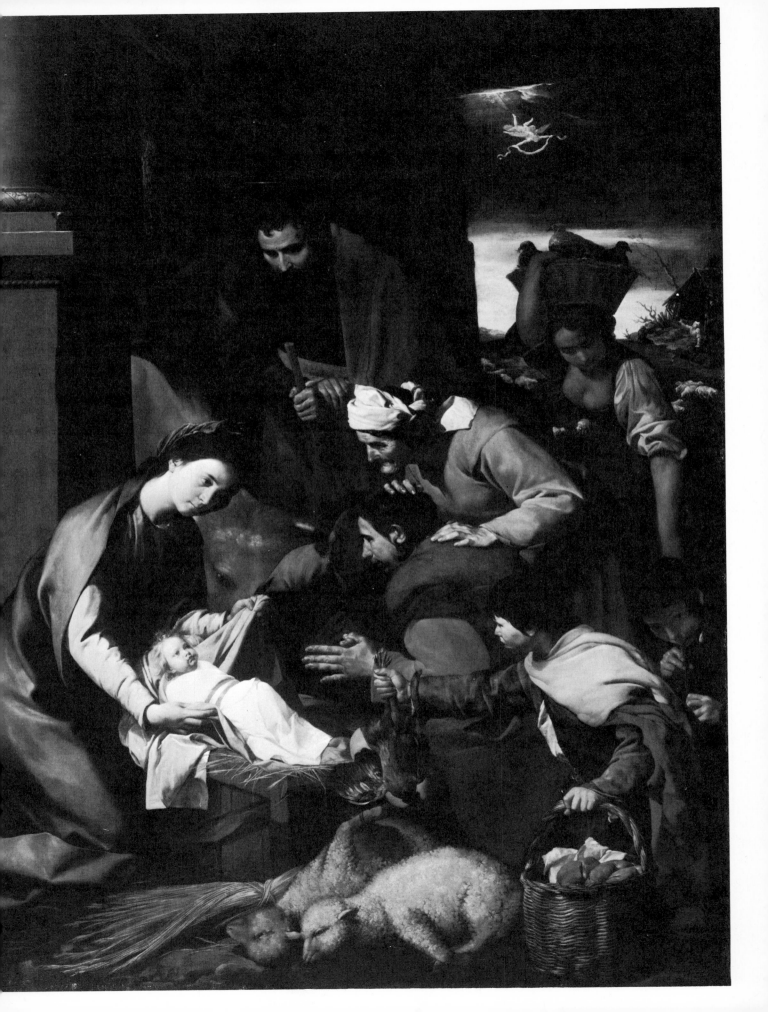

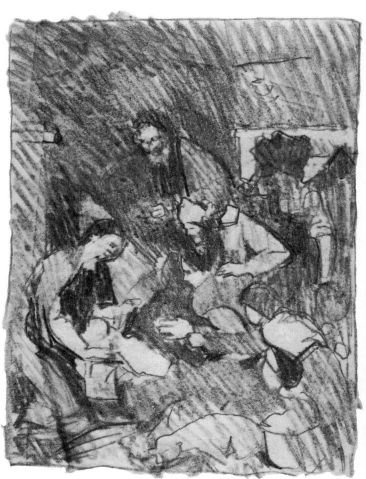

Figure 105. *Here is a rough drawing showing some of the main constructive features of the painting in Fig. 104. Note the division of the rectangle into a square and a smaller rectangle, the triangular shape of the main group, and some of the smaller "connections" within this triangle.*

Figure 106. *The smaller shapes echo the larger ones in this tonal analysis.*

Figure 104. Adoration of the Shepherds. *Seville school, seventeenth century. National Gallery, London. This beautifully constructed composition has a strong geometrical framework; far from making it cold or academic, this adds to the intensity of its human content.*

the standing man. The tip of this triangle ends at a distinct division across the upper part of the canvas which is marked by the capital of the column on the left side, and by the line of light in the sky on the right. This line, in effect, divides the rectangle into a rough square at the bottom and a smaller square at the top.

If we look a little further, we find another square within this lower one. Both share the same top line—the line of capital and sky—but the left side of the smaller square is marked by the edge of the column, and the right side by the vertical of the girl's arm. The bottom of the square is demarcated by a broken but readable line along the rushes, the sheep's back, and the basket on the right. A diagonal dividing this square from left to right is hinted at.

Here we have a basic framework which is very calm and stable: a big square, with a triangle and another square in it. The next important factor in the design is the circular movement which swings around inside these calm divisions. Indeed, this element is so strong that the painter could be accused of showing his hand too much. These geometrical devices are likely to be more effective if hinted at rather than rubbed in too clearly. The circular movement in this picture is inescapable as it runs around the Madonna's head and arm, then is taken up again by the boy's arm on the right and by the stooping old woman. A smaller, tilted circle is concentrated under the apex of the triangle.

If you continue to study the painting, you'll dis-

cover a subtle, tilted square germinated by the strong oblique right angle of the child and the piece of drapery, leading up to the old woman's head, and then carried back down her upper arm and the boy's forearm.

Any analysis of this kind is bound to seem pedestrian, if not tiresomely obvious, so perhaps it would be as well to stop here and allow the diagrams to amplify these points. The rough sketch (Fig. 105) shows some of the main features I've been talking about. The tonal analysis (Fig. 106) explores how the big light and dark shapes clothe this skeleton, and the way that smaller shapes echo and "rhyme with" the bigger ones in a descending series of relationships.

We previously discussed the centers of pictures from a physical point of view. Besides the geometric center, a painting also has an emotional center, what you might call its human focus. The emotional center of *Adoration of the Shepherds* is the area enclosed by the small circle referred to above. In this case, the formal focus, or center of the design, is placed at the same point. Even when the emotional focus is placed off center, the actual middle of the canvas should still be considered. Notice how the painter has gently emphasized the vertical central axis of his canvas with the line of the two profiles, the boy's hand, and the edge of the cloak above. This slightly oblique line parallels the sharp line of the doorway just enough to make a reference to this important division.

34
RHYTHMS
AND
CONNECTIONS

The rhythms which run through a picture need not be obvious. Sometimes they'll hardly be noticed—without being pointed out—by anyone except the painter; and sometimes not even by him. Yet they are there, below the surface so to speak, connecting and leading on from one form to another.

I mentioned in Section 33, in analyzing the *Adoration of the Shepherds,* how geometrical relationships can be set up clearly, or merely hinted at, by strong directions of forms. These directions need not directly connect with one another; they can be at different sides of the picture and still make contact, like people waving to each other in a crowd. For instance, in the *Adoration of the Shepherds* you saw how the right angle formed by the baby's draperies is echoed by the parallel angles of the shepherd's arm and the boy's arm below Another instance is the strong near-vertical of the top shepherd's cloak, which, if continued, would meet the outstretched arm of the boy, again at a right angle.

These are examples of directions which can be linked with others at right angles. This will be found to be a very useful traditional device for linking and locking together the design of a picture.

The rhythmic connections which may be found in landscape are more subtle and less geometrical. A good example is shown in Fig. 107. This Italian landscape contains a series of subtly interconnecting and weaving directions, which have been simplified in the diagram in Fig. 108.

The discovery of such connections in the course of painting is one of the pleasures of working from nature, and one which is unknown to those critics who think that all one is doing is "copying." The full complexity of rhythm in any subject can only be discovered in the course of long and meditative study of the subject—as a by-product, so to speak, of the attempt to realize the shapes and directions as completely as possible.

The repetition of shape, the way that one piece can echo another, plays its part in this linking-up process too. In the landscape there are innumerable variations on the V-shape, which is stated, as if it were the theme in a piece of music, on the bottom edge of the picture.

Figure 108. *Here is a diagram showing some of the rhythms that flow through the landscape illustrated in Fig. 107.*

Figure 107. *Diana Armfield:* Landscape in Tuscany. *Collection J. T. Burns. This small landscape contains a number of subtle, interweaving rhythms, all of which have been discovered in the subject.*

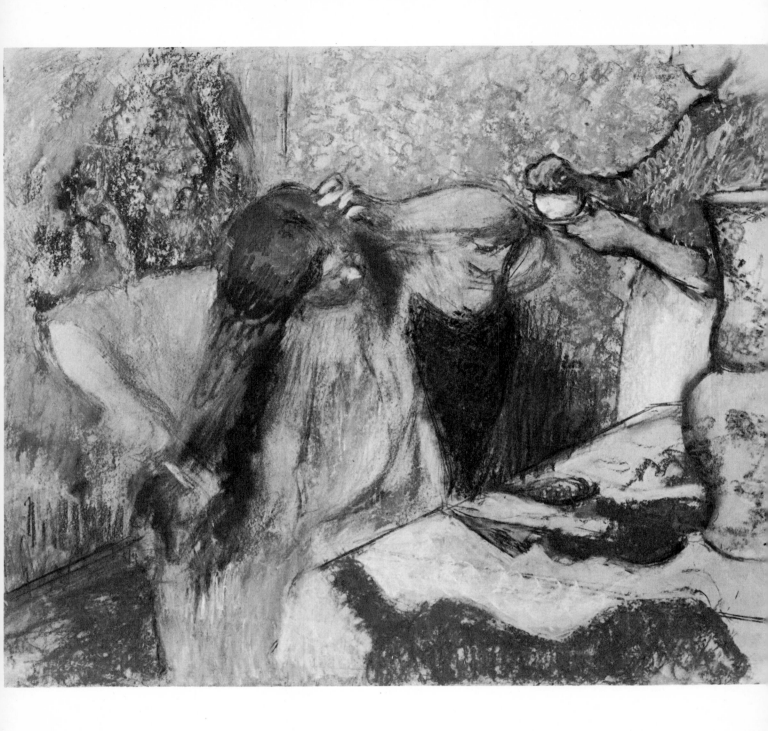

Figure 109. *Edgar Degas:* Woman at Her Toilet. *Tate Gallery, London. Here is a design that is full of rhythmic connections. Directions at right angles, or nearly so, and parallels echoing each other are used in a masterly way. Note, too, the variety of emphasis given to the edge of the forms—an important factor in accenting or in playing down various directions.*

In the pastel by Degas (Fig. 109), the design is, so to speak, "strung around" the big diagonal of the table. At right angles to this, or nearly so, is the side of the woman's dress and the background shape behind her. The V of her bent arm at the left side of the picture is echoed and turned around in various ways by the dark shadow in the middle, and by the hands holding the cup.

One more point, shown very clearly in this picture, is the way that connections can be played down or emphasized by the quality of the shape and edge at important points. Look at the difference of accent between the various arms and hands in this picture.

See how the bent arm on the left side is understated, almost blurred; the angle it makes is quite strong enough, without accents. The other hand, at the woman's head, is comparatively sharply stated in a superb passage of draftsmanship, while the hands and arms which hold the cup are even more definitely outlined. What a variety of edge Degas is able to use, without the slightest loss of unity!

Get into the habit of looking for connections of direction and rhythm, not only in pictures, but when using your eyes in everyday life. You may be surprised at the number of these connections you're able to observe.

35
CIRCLES AND ODD SHAPES

A good way to sharpen your awareness of the relationship of design to picture space is by executing an odd-shaped painting. As soon as you work on an oval or circular format or a straight-sided figure such as an octagon, nothing can be taken for granted. The demands of the format alter and, to a large extent, dictate the whole character of the design.

The almost exclusive use of the rectangular shape is attributable, to some extent, to economic factors. When pictures of the past were commissioned for architectural settings, they were painted in a variety of shapes. As soon as they were executed to be exhibited and hung on walls surrounded by other pictures, the rectangle became the norm; and to deviate from it meant that one's work would be neither hung nor sold. Nevertheless, the shape of a canvas is not sacrosanct. If you feel the corners are unnecessary, there is nothing to prevent you from drawing an oval within them. A piece of board, furthermore, can be cut into any shape that you judge suitable. An oval within a rectangle is a very attractive format, one that was frequently used in the eighteenth century and was given a new lease on life in the period of analytical cubism. Braque and Picasso painted many beautiful pictures in this shape.

Let's tackle the circle, one of the oldest, and perhaps most natural, forms. It relates to our field of vision, which is roughly circular. It is also the most enclosed of all shapes. When you construct forms within a circle, a certain compactness is forced upon you, for the reason that no continuation beyond the confines of the frame is implied. Everything goes on *within* the shape.

Another very important difference between the circle and other formats is its essential instability. It has neither the axis of an oval, nor the straight supporting base of a rectangle. The stability of the design must be established internally, or else there will be a feeling of precarious balance, as if the picture were a wheel which might roll away.

Many circular designs adopt a definite horizontal or vertical motif in order to establish stability. A common circular design, one which we all take for granted, is the coin. Its stability is assured by the vertical axis of the head (Fig. 110).

Because there is no way out of a circle, any design composed within this form must come to terms with its inherent limitation. However, because the circular shape is complete in itself, the eye will weary if equally complete shapes are created inside it. Also, continuously curving or circular movements are very

Figure 110. *A Roman silver medallion (c. A.D. 410) from the British Museum. Strong vertical axes are established on both sides of the coin (for instance, the nose and the piece of drapery under the hair; and on the reverse, the shapes of the throne). Around these verticals, the many curved shapes flow freely, echoing and "rhyming" with the basic circular shape of the coin and the lettering.*

A B C

Figure 111. *Letters are cut from black paper (a). When cut arbitrarily, the letters provide a set of varied shapes (b). These shapes are used as elements in a circular design (c).*

Figure 112. *This drawing after a painting by Hieronymus Bosch shows another solution to the problem of filling a circular format. Here, the elements of the design are naturalistic—a man in a landscape—but the directions are just as carefully related to the outer curve as they are in the medallion illustrated in Fig. 110.*

difficult to handle without merely seeming to repeat the outside shape. Straight directions, on the other hand, or subtly curved rhythms that relate to straight ones, will create equilibrium, yet contribute contrast as they push against the circle.

A limited set of abstract forms can help you explore these possibilities. For instance, cut your own initials out of black paper, in simple, heavy block capitals. Now cut up the letters arbitrarily. The pieces will offer you a simple repertoire of irregular shapes—straight lines, curves, and angles. Cut a circle out of newspaper and push the black shapes about on this circular shape until you feel a design beginning to evolve. Fig. 111 (A, B, and C) shows these stages: first the letters, then the shapes cut from them, and finally two different solutions composed from exactly the same units.

These designs are purely abstract. What sort of figurative subject could you use for a circular picture? The answer is that almost any subject is suitable as long as it really "belongs" and is not merely an excuse for a square picture with the corners lopped off—a solution that rarely works! Figure subjects are probably the most fruitful, as the combination of rounded and angular shapes, and the interlocking movements of several figures in a group, tend to fit comfortably into a circle. A drawing after a picture by Hieronymus Bosch (Fig. 112) and Botticelli's *The Adoration of the Magi* (Fig. 113) offer excellent examples of figures used in a circular composition. Both pictures employ a good deal of centrality and implied symmetry, without allowing these devices to become obvious. This approach is not the one and only way to fill a circle. Instead of stability and centrality, there's no reason why a scattered, all-over pattern should not work equally well.

Figure 113. *Sandro Botticelli:* The Adoration of the Magi. *National Gallery, London.*
A big cross is formed by the architecture and the horizon. Virgin and Child are almost exactly in the center of the circle, and the figures make converging movements from the foreground toward them. Note two things: the other, flattened, circle seen in perspective formed by the figures behind the Virgin, and the shapes formed by the group in the middle foreground, a sinuous, rhythmic parody of the severe verticals of the architecture.

36
PAINTING
WHAT'S THERE:
SOME STUDENT
PICTURES

A class of beginning painters was given quite a complex subject that included a woman in a striped dress, a blue table with a plant on it, patterned fabrics, and the general clutter of an art school studio. Some of the students had never before done an oil painting. For some of them, it was the first time they had been faced with such a complicated problem.

The resulting paintings (Figs. 114-118) offer a refreshing change, in a book like this, from reproductions of the masters. The pictures are naive, partly because the students were encouraged to leave nothing out, to use every form and patch of color which came into the particular rectangle of vision they chose. They were also asked to make their pictures out of the whole setup, rather than to concentrate on the figure alone.

Their struggle to organize so many elements was not always successful; the pictures are often stumbling or unresolved. But what they gained from this difficult project makes their pictures as valuable to discuss as paintings by more accomplished artists.

First, note the vigor and the interesting quality of the shapes. Because the students accepted everything in front of them as being of equal potential importance, they were able to discover useful or odd shapes in every part of the picture. More selfconscious amateur painters (and many professional ones) would have left out the gritty and uncompromising black studio heater, which appears with such good effect at the extreme left of Fig. 115 and behind the woman in Fig. 116.

Secondly, consider the importance of the relatively flat areas of paint. The actual color of the subject was strong and fresh. These students did not adulterate this strength by too much modeling or light and shade. Moreover, building up the picture by means only of flat areas of color allows every shape to be given its full value. The areas in Fig. 117 may be clumsily and awkwardly juxtaposed, but at least they are decisive and strong. Subtlety can come later.

A third point to note is the fact that five individuals created five quite different paintings even though their subject and approach were identical.

Figure 114. *This quirkily observant painting of a figure in relation to its surroundings was done by a young student, as were the four which follow. They were the first paintings these particular students had ever done in an art school. They were encouraged to put down a statement about the entire scene in front of them, without worrying about their obvious lack of experience in drawing and painting.*

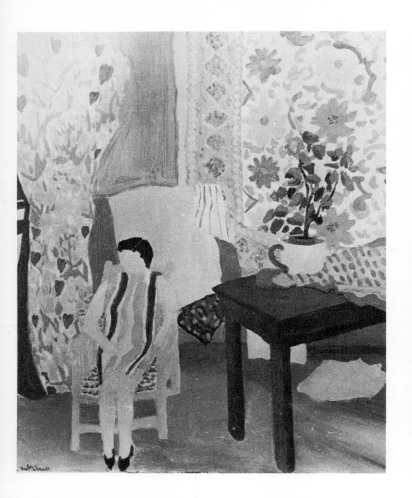

Figure 115. *This student's painting is tentative and gentle.*

Figure 116. *This student's painting is orderly.*

The most experienced of these young students painted both Fig. 114 and Color Plate 17. Here the apparent naiveté of both designs is, in fact, very purposeful. Fig. 114 was painted first; it explores possibilities. The later version is quite consciously painted as if seen from a high viewpoint. The curious tilting perspective, while deliberate, is not selfconsciously childish. The tilting planes, such as the floor and the table, give each element in the design its full decorative potential as a colored shape.

We can learn from paintings like this—just as we can learn from children's drawings—something about the value of big, frank areas of color and the relative unimportance of academic rules.

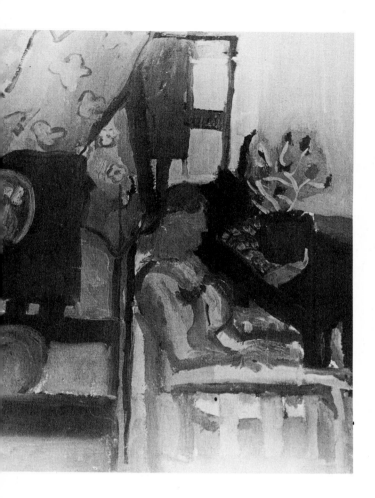

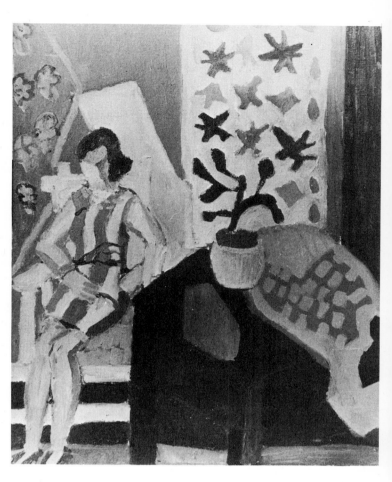

Figure 117. *The areas in this student's painting are clumsy, but vigorous.*

Figure 118. *This student's painting, like Fig. 117, is extroverted and a little heavy-handed.*

37

THE VALUE
OF EMPTY
SPACES

"Agoraphobia" is the medical term for fear of empty spaces. Some painters seem to suffer from this problem when they compose a picture. Equating emptiness with dullness, they avoid it and end up by giving all areas of the canvas equal emphasis.

Actually, no part of a picture can be called empty if it relates to the rest of the canvas. After all, it is covered with paint of a certain color and tone. Then why not consider it positively as a big patch of color, instead of negatively as a mere gap?

Of course, a picture can be intentionally composed of equally stressed small forms that cover the whole surface—a possibility we will discuss in the next section. At the other extreme would be an almost completely "empty" picture, like some of Turner's late seascapes or many modern abstract pictures. Most paintings, however, are built on an alternation of busy and empty areas. This seems quite a natural way of attaining variety of tension, comparable to the use of fast and slow movements in musical form.

An untroubled calm area of the picture surface can be contrasted with small forms or intense color changes that create a strong focus. For example, look again at Color Plate 5, where the wall fills nearly half the picture area and contains only slight modulations of color.

The most obvious kind of contrast between flat and busy is in the use of a simple background. Countless portraits exploit this basic opposition, using flat color as a foil to the small and complex forms of a face. The sky in a landscape can be used in the same way (refer to Figs. 100 and 101).

Many amateurs feel compelled to "break up" flat areas for no particular reason, except that they're afraid of the areas becoming dull. It's true that a flat surface must have a certain beauty of its own. Solid, unmodulated paint can be exquisite in its own right and calls for as much, possibly more, subtlety and decision-making as any other part of a picture.

As an exercise in the use of flat areas, compose a picture in which, say, three-quarters of the space is empty, and a quarter "busy." Choose a subject in which the empty space is not necessarily behind the complex areas (as would be the case in a portrait set against a flat background or a landscape with a big sky; the flat space could just as well come in the extreme foreground or to one side.

38

ALL-OVER
DESIGN

Many painters, from Brueghel and Bosch to Klee and Mark Tobey, have based their pictures on an all-over pattern composed of small units, in contrast to the use of open space we have been discussing.

This type of design demands an active quality in the forms themselves. Their colors and/or shapes should react vigorously against one another in order to generate a feeling of life and movement. In Kandinsky's *Relations,* reproduced in Fig. 119, the small forms dance, wriggle, and flash with a liveliness that is extraordinary, considering that they're completely abstract.

Without the kind of tension you see in the Kandinsky, a static, textile-like surface is established. While a well-designed textile calls for a certain restful stability to keep it from becoming irritating, a painting, because its design is not repeated over and over, can use far more movement and tension.

If you would like to try an experimental composition of this all-over nature, use the fragmented or cut-up letters and numbers described in Section 35. One reason these forms are suitable is that the letter shapes have an inherent tautness and spring; when these shapes are torn or cut, they form useful short curves and definite angles. The collage technique enables you to move the shapes around until their arrangement pleases you.

Disperse your shapes loosely over a plain ground, white or colored. At a later stage, you may like to use the ground more freely—for instance, by painting it where it is exposed around the shapes, or even by overlapping the shapes when they are pasted down. Your aim is to relate the small and rather equal forms to each other so that you build up a sense of movement and tension over the surface.

This approach would be, of course, equally valid if you applied it to a figurative painting. A crowd of figures, for instance, such as you see in many of Brueghel's paintings, can be arranged in just this way.

Figure 119. *Vasily Kandinsky: Relations. Courtesy Marlborough Fine Art, London. An almost manic energy is generated by small, purely abstract forms scattered over the picture surface.*

39
DIVISION OF A RECTANGLE

Except for the type of all-over design discussed in Section 38, the conventional rectangularly shaped picture is likely to be divided either horizontally or vertically. Any landscape, for instance, will contain an important division where the sky meets the land. In fact, it's difficult to place any horizontal across a long rectangle without immediately suggesting the idea of landscape to practically everybody (Fig. 79).

Similarly, a painting of an interior generally has vertical divisions such as walls and a door. Even if one can't actually see a line moving from side to side or from top to bottom, these divisions are often hinted at by strong directions within the picture area—for instance, the chimney that connects with the figure in Seurat's *The Bridge at Courbevoie* (Fig. 124).

As soon as we make these divisions we're dealing with one or more rectangles or squares. In the past, a great deal of thought and academic theory has been expended on the various ways the picture space can be divided with vertical and horizontal lines.

For instance, innumerable painters of the past used the very simple and ancient approach of dividing any rectangle into a square and another (usually smaller) rectangle. You can think of this division as formed by dropping the shorter side down against the longer side. The point where it falls is where the division is constructed (Fig. 120, left). The technical name for this very strong and secure division is the *rabatment* of the rectangle. The measurement, of course, doesn't need to be absolutely precise.

Piero della Francesca continually used this compositional structure, often defining the square by placing architecture behind his figures. He obviously valued the way the *rabatment* anchors a design calmly and firmly. Fig. 121, a drawing after one of this artist's frescoes at Arezzo, illustrates this point.

Fig. 122, a small painting by Carel Fabritius, shows a very thoughtful division of a long rectangle which, in fact, is slightly wider than a double square. The church tower is placed in the actual middle, while the main pictorial division occurs a little to the left of the square. The square itself is established by the projecting dark eave. The vertical, which might otherwise be too abrupt, is broken by the overhanging sign; and the abrupt transition from the light sky to the dark is softened by the vertical stripes of the slats.

We can go on from here in this basic geometric approach (Fig. 120, right), by making two *rabatments* that divide the rectangle into three parts, then adding diagonal lines from each corner. The points where these diagonals intersect the vertical *rabatments* used

Figure 120. Rabatment of a rectangle. *A square is formed, using the shorter side of the rectangle. This divides the original format into a square and a smaller, upright rectangle (left). Two overlapping squares in a rectangle formed by rabatment (right). The points at which their diagonals cross are known as the "eyes" of the rectangle; they used to be considered by some geometrically-minded artists as especially important points.*

Figure 121. *A drawing after a fresco by Piero della Francesca at Arezzo,* The Queen of Sheba before Solomon. *The square which is formed by the architecture behind the figures provides a firm basis for the composition.*

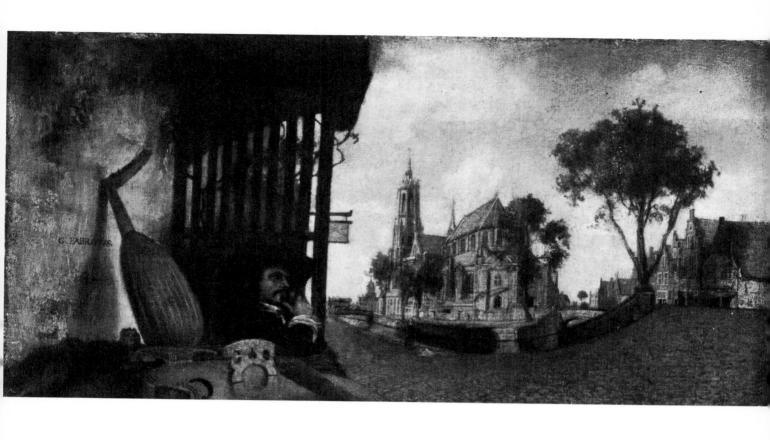

Figure 122. *Carel Fabritius:* View of Delft. *National Gallery, London. This is a tiny picture, only a few inches wide, but the artist has designed it with as much concentration and learning as if it were a large and important picture.*

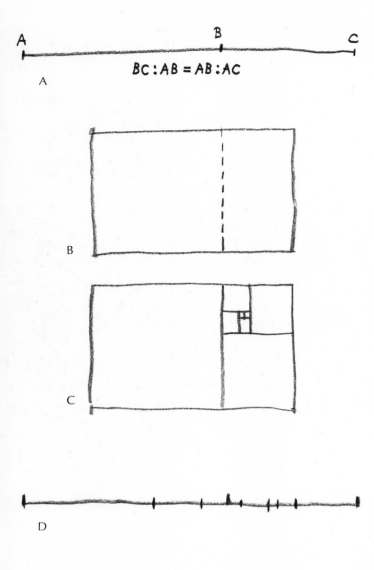

$$BC : AB = AB : AC$$

Figure 123. (a) *In the golden section division of a line, the ratio of BC to AB is the same as the ratio of AB to the whole length of AC. (b) A golden section rectangle. When a square is formed in the rectangle, by dropping the short side onto the longer, the smaller upright rectangle left is also a golden section rectangle. (c) The division into squares and golden section rectangles can go on to infinity. (d) None of these distances is the same width.*

to be called the "eyes" of the rectangle and were considered important focal points in the design. This point of view, though somewhat dubious, is worth mentioning.

The ratio known as the "golden section" is another well-known and traditional device for dividing the picture space. As briefly as possible, the golden section expresses a ratio between two lengths in which the shorter is to the longer as the longer is to the whole. In case that formula seems to you both baffling and useless, look at Fig. 123A. The curious thing about this ratio (which is actually 1:1.618, or roughly 8:13) is that it's unique.

A golden section rectangle (Fig. 123B) is composed of sides which express this ratio. Now, if we make a square in the rectangle, in the same way as Fig. 120 (left), the resulting smaller rectangle also has the proportions of the golden section. Like the ratio on which it's based, this is the only rectangle which behaves in this way. The division can be continued indefinitely, into ever smaller squares and golden section rectangles (Fig. 123C).

Although all the divisions in the golden section have the same *proportion,* none is equal in *size.* This fact suggests a way of using the golden section to our advantage. It's possible with this formula to make an infinite series of points or divisions, all of which would be unequally spaced. None of the distances in Fig. 123D is repeated. We all have a tendency, especially when we're not thinking very hard, to repeat the same shape or the same distance in a design. But if we use the golden section ratio, this kind of repetition is impossible. (Sometimes one wants to do this, of course, but not always.)

The Bridge at Courbevoie, by Seurat (Fig. 124), shows how a rectangle can be divided by a series of intervals—here formed by the masts, chimney, tree, and figures—in such a way that none of the spaces thus created is monotonously equal. I haven't, I admit, measured this picture with a ruler, and neither do I intend to; but I shouldn't be at all surprised to find that Seurat had used the golden section in a very free way here. It's quite possible, in fact, that he arrived intuitively at the divisions, in which case they're not measurable.

I think that artists like Seurat and Degas knew all about systems of proportion, but never applied them rigidly. The geometry of pictures like *The Bridge at Courbevoie* (Fig. 124) or like Degas' *Jockeys avant la Course* (Fig. 125) is flexible, unforced, and always dependent on factors other than just the linear net-

Figure 124. *Georges Seurat:* The Bridge at Courbevoie. *Courtauld Collection, University of London. The divisions formed by the masts, trees, chimneys, and figures are very sensitively adjusted so that none of the intervals is monotonously equal. Many of them are of golden section proportion.*

Figure 125. *A drawing after Edgar Degas'* Jockeys avant la Course. *Again and again, the golden section proportion can be found in this painting: the upright post cuts across the width of the canvas in this proportion; the sun, in relation to the larger of the two widths thus formed, is placed exactly on the golden section; the head of the jockey on the right comes in the same position in relation to the smaller width. These are some of the more obvious golden section divisions in the design, but there are plenty of others as well.*

work. The placing of a form must always be modified by the color, tone, and emotional content of the picture, as well as its geometry.

Nevertheless, so many critical points in *Jockeys avant la Course* are placed on or very near the golden section that the composition can hardly be accidental: for example, the big upright post cuts the width of the canvas; the horse's ear cuts the space from the post to the foreground jockey's head; the small distant post on the left cuts the space from the left edge to the distant horse's rump. See how many more golden section divisions, and additional geo-metric proportions such as squares, you can find in this picture.

Of course, no one point in the picture space has an inherently greater virtue than another. A picture is certainly not improved simply because something in it happens to come on a square or a golden section. Such a geometric approach can easily become a rigid and academic formula unless it is illumined by good ideas and good painting. On the other hand, hidden geometry of this kind, when properly used and not merely exploited, can increase the intensity and the logic of a design.

40
DESIGN
IN TERMS
OF TONE

Pictorial composition is sometimes discussed exclusively in terms of line. The diagrams one sometimes sees which reduce an old master picture to dotted lines and diagonals may be partly responsible for this idea. Nevertheless, most paintings are constructed from masses rather than from line. These masses, or shapes, can be made up of strong color, or they can be largely tonal. Most good pictures, however full of color they may be, can still be reduced to arrangements of dark and light shapes. Take away their color and recognizable subject matter, and the remaining tonal pattern will still provide a satisfactory and self-sufficient design. The average painting, however, cannot be reduced in this way without resulting in a jumble.

A good way to learn about this tonal structure is to make a simplified version of an old master painting, using only a few tones. Many people are inclined to shy away from any idea that suggests "copying." This exercise is more than a question of imitation. The point is to transcribe a work of art in order to find out how it works.

Throughout the history of European art, great painters have studied their predecessors: Rubens copied Titian; Rembrandt made studies after Raphael and Indian miniatures; and, more recently, Picasso has executed whole series of "variations" on such artists as Delacroix, Cranach, and Velasquez. If artists of this stature do not hesitate to learn from other painters by studying and imitating their works, why should we?

There are many different ways of executing a free copy. For our purpose—to increase our understanding of tonal shapes and pattern—I suggest you take a picture that offers complex shapes and a vigorous design. A figure composition will probably be more fruitful than a landscape or a portrait; the painting by Hieronymus Bosch (Fig. 126) which I have chosen as an example is ideal.

Although you could make a tonal study in charcoal or paint, I suggest that you execute it in collage—that is, paper of different tones, torn to shape and glued down (Fig. 127). The advantage of the medium of collage is that it forces you to simplify; moreover,

Figure 126. *Hieronymus Bosch: The Mocking of Christ. National Gallery, London. I have chosen this picture as the basis for a transcription exercise because it has a fairly bold patterning of light and dark, as well as a closely-knit and complex design; although most people will probably be impressed first by the human drama and the marvelous observation of character and facial expression.*

Figure 127. *This collage version of Fig. 126 was made by tearing and pasting black, white, and gray paper. Complicated shapes have been built up by sticking patches down over one another. The aim of this transcription is to examine the total pattern of the picture—the way that dark and light shapes are related to each other.*

alterations are easily made by gluing one patch of paper over another.

A wide variety of gray tones can be found in magazine photographs or advertisements. Tear the paper rather than cut it with scissors or a knife. Tearing keeps the shapes very simple; the irregular edges prevent the shapes from getting a hard and cut-out look. Big or complex shapes can be made up by gluing several smaller pieces down, one over the other.

The best way to glue the paper is with wallpaper paste, which can be mixed a little at a time in a cup, then brushed right across the surface. Wallpaper paste is colorless when dry. As it exerts a certain pull when drying, it may be advisable to use a heavy paper or cardboard as a support for your papers.

Try to decide on the minimum number of tones that can be used. Some pictures can be radically simplified to a black tone, a white tone, and a couple of halftones. Put down the big shapes first; then, if necessary, break them up. Remember that the idea is to simplify, not make an accurate copy. Therefore, you need only state the bare bones of the picture in terms of its tonal pattern. Wherever possible, try to bring together several elements which are tonally similar into one large area, instead of thinking in terms of separate arms, legs, and so on. Sometimes it helps to work with both the original and your collage upside-down.

The study after Bosch (Fig. 127) was carried out on gray paper, a useful middle tone on which to place the lights and darks. I made no preparatory drawing, but merely indicated the rectangle's proportions. It is very important, by the way, to reproduce the proportions accurately in your collage.

Not all pictures lend themselves to this treatment. An Impressionist landscape, which depends more on color changes than on tonal pattern, would be almost impossible to use. You need a picture which has well-defined shapes and a fairly wide tonal range.

41

A TRANSCRIPTION
BASED ON
A COLLAGE

While I was working on the preceding exercise (Section 40), I found it useful at times to lay the collage and the original painting on their sides or to put them upside-down, and to continue working from this changed viewpoint. Working in this way can give you a new and refreshing view of a familiar picture—in this case, modifying a too intense concentration on the figure as an individual, and enabling you to see her as one shape among other shapes.

Here, perhaps, I should digress to say that there's no particular virtue in looking at a picture as an abstract design. To do this may sometimes be necessary and useful, as in this exercise, but I don't wish to suggest that the subject of a picture has no importance. On the contrary, I think that the subject is of paramount importance. Nevertheless, it's useful to be able to visualize and to think in abstract terms.

There is another collage version (Fig. 129) of a well-known picture, Vermeer's *A Lady at the Virginals* (Fig. 128). Having studied the collage by turning it on its side, I saw that it made rather a satisfactory and quite new design. The large flat areas contrasted with the busier part around the figure, suggesting the concept of "landscape" rather than, as in the original, a figure in an interior.

I decided to carry this transcription on to a second stage by executing a free painting after the collage (see Color Plate 18). To do this, I retained the sideways-on format, painting for a long time with the collage in front of me this way up. I was not consciously trying to make the painting into a landscape, yet the sensation of landscape had something to do with the development of the painting.

I looked at the collage for quite a time before I started to paint, trying to decide what shapes and rhythms seemed important and what range of colors I wanted to use. I don't really like to decide such questions arbitrarily; to say, "I want to do a pink and green painting" seems to me a curiously detached approach when so many color combinations are all around us, any of them enough to start with. In this case, I found myself remembering the colors in a postcard that I had been looking at the day before: a detail of a fresco by Lorenzetti in Siena. I rummaged about, found the card, and pinned it to the easel. It gave me a starting point, though I departed considerably from the actual colors as the painting proceeded. I retained the tonal balance of the collage, seeing no particular reason for changing it. It was quite interesting, at the end of this experiment, to turn the painting

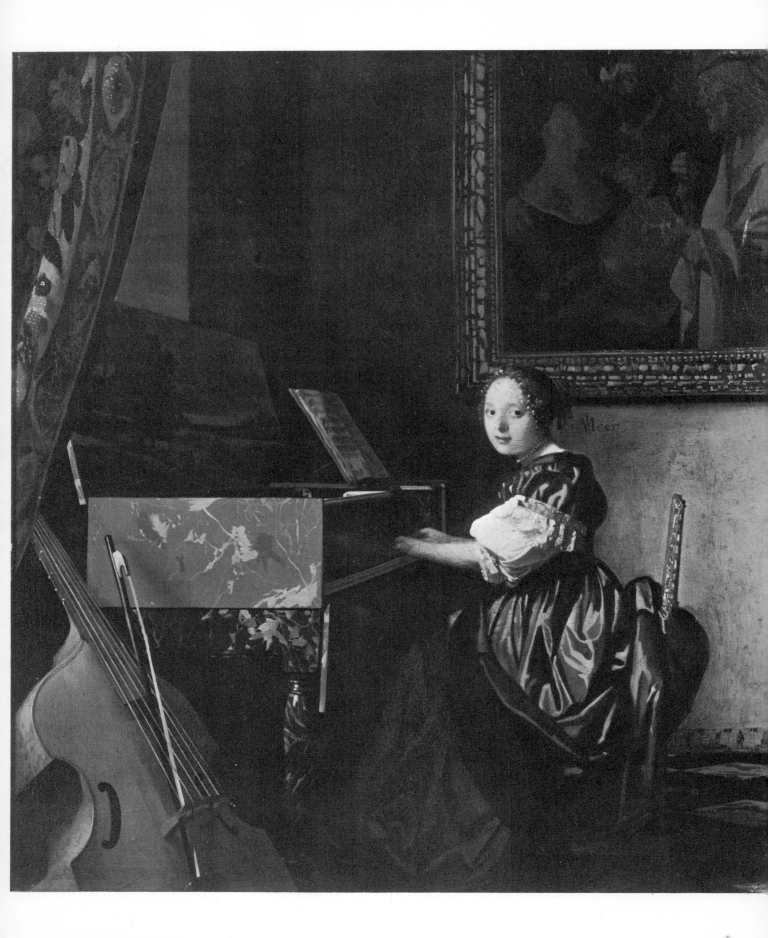

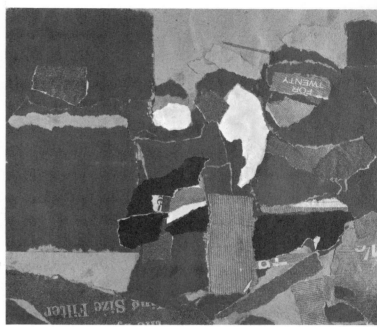

Figure 129. *A collage in monochrome (left), made up of torn paper and serving as the first stage in doing a transcription. If the collage is placed on its side (right) when starting the painting from it, the character of the shapes, seen as pure shapes, becomes more apparent.*

Figure 128. *Jan Vermeer:* A Lady at the Virginals. National *Gallery, London. The shapes in this picture are extremely varied, making it a good example to use for a transcription exercise. Notice the contrast between large, comparatively empty spaces and smaller, complex ones.*

around and see that the Vermeer was still there, having passed through two stages of transposition.

However, having arrived at this stage, I began to work back to Vermeer, for I find it quite impossible to sustain my interest in an abstraction. To look at a picture as an abstract design is for me a useful and necessary stage. When I paint anything that is at all large or complex, not only do I turn the canvas upside-down to see it freshly, I also sometimes work on it that way up. But I always get back to the subject in the end. Here, for example, the fact that the picture concerns a woman seated at an instrument was more interesting to me than playing around with the abstract shapes that composed it.

The collage, though not an end in itself, served a purpose: to get me to put down, in very simple terms, the bare bones of the design. Once this task was accomplished, I dug out a monochrome postcard of the original Vermeer painting, placed it in front of me, and developed my version of it further. What had been a simplified shape in the collage again became increasingly complex as I worked.

The picture, in short, had made something of a round trip. The purpose? Simply to explore how, starting from a fixed point, one can find out something about a particular aspect of a painting—in this case, about how far one can travel from the original work without losing touch.

Of course, a transcription like this one could develop in innumerable different ways. It could, for example, be transformed into a different figurative picture, in which the same design and shapes were used for another subject. Some art schools require every painting student to do one or more transcriptions from old master paintings. Sometimes the results are very far from the originals, just as in music a composer's variations on a theme may lead him very far away from the starting point.

As soon as you work from another picture, you modify or alter it to some extent. This kind of change inevitably occurs because you're using methods and materials that belong to your own era, and because you're looking at the picture you're working from with contemporary eyes.

CONCLUSION

It's difficult to avoid giving the impression, in a book like this, that every aspect of drawing and painting has been neatly parceled up, labeled and systematized. Throughout this book, I have been very conscious of the danger of falling into that didactic tone which says, "This is the proper way to do it."

It can become tiresome to be always qualifying, always putting in asides to say that this is only one suggestion and you must work out your own methods in the end. But this is very much what I mean. This book has really only one purpose—to point out ways in which our eyes may be opened a little to relationships, both in nature and in art.

It is all too easy, when suggesting a direction or a point of view which may help, to wrongly give the reader an impression that the course of action proposed is an end in itself, "the right way." I will say it again, and for the last time—this book is only a set of suggestions toward broadening our seeing, *not* a set of formulas for making acceptable pictures.

INDEX A

R

S

T

U

V

W

Edited by Margit Malmstrom
Designed by james Craig
Set in ten point Optima by York Typesetting Co., Inc.
Printed and bound by Halliday Lithograph Corp.
Color printed by Algen Press